Emancipating Lincoln

The Nathan I. Huggins Lectures

EMANCIPATING LINCOLN

*The Proclamation in
Text, Context, and Memory*

Harold Holzer

HARVARD UNIVERSITY PRESS

Cambridge, Massachusetts, and London, England

2012

"Lincoln Monument: Washington" from *The Collected Poems of Langston Hughes* by Langston Hughes, edited by Arnold Rampersad with David Roessel, Associate Editor, copyright © 1994 by the Estate of Langston Hughes. Used by permission of Alfred A. Knopf, a division of Random House, Inc., and by permission of Harold Ober Associates Incorporated.

Library of Congress Cataloging-in-Publication Data

Holzer, Harold.
Emancipating Lincoln : the proclamation in text,
context, and memory / Harold Holzer.
p. cm.
Includes bibliographical references and index.
ISBN 978-0-674-06440-9 (alk. paper)
1. United States. President (1861-1865 : Lincoln). Emancipation
Proclamation. 2. Lincoln, Abraham, 1809-1865—Views on slavery.
3. United States—Politics and government—1861-1865. 4. Slaves—
Emancipation—United States. I. Title.
E453.H644 2012
973.7'14—dc23 2011035161

For Skip Gates, with admiration and appreciation

Contents

Emancipating Lincoln

Introduction

The world has never had a good definition of the word liberty," Abraham Lincoln confessed more than a year after issuing the Emancipation Proclamation, "and the American people, just now, are much in want of one."[1]

The quest for a universally accepted definition has continued ever since. When the Civil War ended in the spring of 1865, the boundaries of American freedom were at least more precisely defined: they restricted the liberty of individual states to depart at will from the American union, and vastly expanded that of African Americans long held in slavery. Yet while history has consistently acknowledged Lincoln's leadership in preserving the Union, the credit he once automatically and universally received for accomplishing reunification accompanied by a "new birth of freedom" has become a matter of dispute—in fact, increasingly so.[2] Evolving national memory—abetted by generations of vigorous and increasingly harsh revisionist scholarship—has not been particularly

kind to Abraham Lincoln's Emancipation Proclamation or his leadership in hastening the destruction of American slavery and with it, the redefinition of American liberty.

A document regarded in its own time with so much trepidation and outright fear that it provoked Wall Street panic, Union troop desertion, bellicose foreign condemnation, vast racial unease, and severe political rebuke from voters at the polls, it is now often viewed not as revolutionary but as delayed, insufficient, and insincere. Its author, condemned for his actions by anxious contemporaries, was later celebrated for and closely identified with the achievement through much of the later nineteenth century by whites and blacks alike, who called Lincoln "the Great Emancipator." But that term is now generally considered politically incorrect, and Lincoln's entire reputation as an anti-slavery leader has been called repeatedly into question. No wonder revisionists have been debating Lincoln's intentions—and with particular emphasis since African Americans achieved their "second emancipation" in the era of the civil rights movement a century after Lincoln.

Recently Lincoln has come under such intense scrutiny over his purported motives and mysterious timing for emancipation that in some circles he has retreated in reputation from liberator to obstructionist. To his most unforgiving critics, Lincoln was nothing more than a

racist who acted on slavery not out of conscience but from desperation. Even as a new generation of scholars renews the debate on the proclamation and its impact, it has become increasingly difficult to discern which oversimplified vision of Lincoln's most important act does a greater disservice to history. The question of whether Lincoln was an enthusiastic or reluctant emancipator continues to test our will to understand the complex past as its participants lived it.

This collection does not propose to retreat to the (wisely discarded) grossly oversimplified version of the events of 1862 and 1863, or to substitute a new or revived antique exaggeration for a contemporary one. Though not a narrative history of the Emancipation Proclamation, it proposes to reintroduce authenticity to this crucial discussion by revisiting the document (and its author) at the very moment of its creation and by exploring its impact during the decisive months and years that immediately followed. It attempts to peel away the layers of myth and misunderstanding that have clouded the reputation of both "emancipator" and emancipation, making it so difficult to discern, much less accept, the proclamation's impact in its own time. To refocus the inquiry, it attempts to direct historical attention to the political, military, public relations, and legal realities that Lincoln himself confronted and juggled—not always with perfect success—as he attempted to strike a blow against

an institution he had reviled all his life but which, until rebellion made its destruction possible, he had concluded he had no constitutional right to challenge.

In recalling Lincoln's extraordinary skills as a political strategist, moral voice, peerless prose writer, and ultimately a living and then martyred symbol of freedom, it seeks to revisit the almost incomprehensibly severe pressures under which he labored. It attempts to comprehend the convoluted route he took before he revealed his decision, and to acknowledge the outright disinformation he promulgated, ostensibly to prepare the public for his decision. It will parse the actual words he employed (or rejected) to execute what he himself regarded as the "greatest act" of his administration, yet maddeningly seemed to craft and announce as if it was routine and unremarkable. And it will trace the evolution of Lincoln's own resulting reputation as a liberator, as vivified in words and images alike.

But as this book will argue, modern historians who ill-advisedly apply twenty-first-century mores to a nineteenth-century man are not the only culprits who have made it difficult to see the proclamation within the context of its own time. Lincoln himself is to blame for much of the confusion. He complicated the announcement of his order with such obfuscatory and misleading feints that it is little wonder the public had trouble then—and has continued to have problems ever

since—in discerning his true motivations. It was Lincoln who cloaked them in misinformation.

In Chapter 1, these complex diversionary tactics are recalled, set in chronological, military, and political contexts, and reanalyzed, with a special focus on the long-voluble orator's frustrating silence during the extended run-up to emancipation. Lincoln may emerge as a preternaturally crafty manipulator of public opinion and the press as he labors to make a truly society-altering order palatable to the widest possible number of Americans. It will no doubt seem reasonable to wonder anew whether he may have vastly underestimated the ability of white Northerners to embrace the notion of black freedom—thereby injuring his future reputation for earnestness on the subject of freedom.

As Chapter 2 will acknowledge, even when he finally concluded that the timing was right to announce emancipation to the public, Lincoln tamped down its potential status as American gospel by couching his order in uncharacteristically leaden language. Although he privately explained at the time that his goal was to construct a document sturdy enough to withstand future court challenges, Lincoln could easily have introduced or concluded its dry legalese with the kind of soaring rhetoric of which the public knew he was capable. Why he opted to do otherwise in January once he had unleashed the bombshell of the preliminary proclamation the

previous September is the subject explored in this chapter. In addition to probing Lincoln's creative (or in some cases not-so-creative) impulses, it also asks whether the words that Lincoln later offered in both speeches and public letters to defend and promote emancipation ought to qualify in the historical record as the poetic accompaniment to the prose with which he first announced his proclamation. It is meant to remind readers that while Lincoln's January 1, 1863, order was never overturned in law, the jury is still out, the final verdict still due, on the question and limits of his absolute devotion to human freedom.

Finally, I am particularly gratified to have the opportunity in Chapter 3 to return here to a subject especially dear to my heart: the exploration of Lincoln's subsequent reputation as an emancipator through iconography, the study of pictorial relics as historical evidence. Here I return to the Day of Jubilee to apply thirty-five years of study in this field to a new, comprehensive, and hopefully definitive summary of the complex, ever-changing visual image of Lincoln as an emancipator. For too long (aided, it must be admitted, by some of my own rather callow early forays on the subject) it has been mistakenly assumed that American image makers greeted news of the proclamation by promptly and ever after celebrating its author as a liberator, creating and cementing for him an iconic status that only recent cynicism has challenged.

Further study reveals that the image makers' introduction of Lincoln's transfigured image actually took surprisingly long to reach the public, and in the bargain inspired decidedly more visual opposition than hitherto understood. The final chapter of this book examines and illustrates the timing and breadth of the immediate visual response to black freedom, beginning with the manner in which artists initially treated emancipation primarily as a campaign issue, not as a society-altering upheaval. Only later, it will be suggested, did they seize on Lincoln's assassination and martyrdom to belatedly but indelibly introduce emancipation as a theme of pictorial tributes. They did so, it is crucial to keep in mind, in an age in which Americans elevated Lincoln to the realm of national sainthood and venerated his pictures as domestic icons. Finally, the chapter also examines the ways in which more modern artists, white and black alike, creating works for broader public display, subsequently reinterpreted freedom not as a fact fixed in history by Lincoln's act but as a vexingly elusive goal, or to use Lincoln's own words, America's "unfinished work."

These essays may not immediately or conclusively alter the course of Emancipation Proclamation historiography, change the reputation of the man who wrote the proclamation, or close the books on analysis of the commercial-minded picture publishers who sought an audience for Lincoln's image as a liberator. I hope,

however, they will emphasize the complicated nature of the painfully slow march that all Americans—white and black, leaders and constituents—took toward freedom in 1862 and 1863. Ideally it will stimulate further conversation based not just on our own modern concepts of liberty and equality but also on the opportunities and limits that confronted Abraham Lincoln. I hope particularly that it will renew appreciation for the imperfect but determined manner in which Lincoln, despite all his understandable uncertainty, somehow managed to father his "new birth of freedom" in the unprecedented crucible of disunion and civil war.

I

The Bow of Promise

The oddly compelling phrase "bow of promise" comes directly from Frederick Douglass—from his *second* most famous speech about Abraham Lincoln: not the one he delivered on April 14, 1876, in unveiling the Freedmen's Monument in Washington, but rather the eulogy he offered at the site of the late president's most famous prewar speech, Cooper Union in New York City, eleven years earlier on June 1, 1865.

In that initial oration, Douglass spoke of Lincoln as "emphatically the black man's president . . . the first of the long line to show any respect to the rights of the black man." In the second he called him "preeminently the *white* man's President" (emphasis added) and African Americans "at best only his stepchildren; children by adoption, children by forces of circumstances and necessity."[1] The second speech has been widely quoted, the first largely forgotten. They cry out to be reexamined and compared, because they help open a window onto the complicated evolution of African American—in fact

all American—memory of Lincoln, slavery, and freedom, and because they inform the historical hung jury that continues to deliberate Abraham Lincoln's claim to the title of emancipator, with no final resolution in sight.

One is unlikely to resolve the case on these pages, but revisiting some of the neglected evidence, authoritative and circumstantial alike, can add meaningfully to the record. This opening chapter considers what might be called the "artillery of silence"—an intentional oxymoron that asks readers to consider the idea of inaction as action, and of intentionally misleading public utterances as purposeful and helpful. And it asks readers to consider as well Douglass's comment in his 1865 eulogy that, however complex the forces that ended slavery, Lincoln always held the "bow of promise" in his hands—even if he sometimes inexplicably, even maddeningly, withheld his arrows, or occasionally slung them in oddly chosen directions, as he readied the nation for emancipation.

The story begins with the subject of freedom itself—not the overarching theme of human liberty, but rather the thousand-page novel called *Freedom*, published in 1987 by William Safire. Most Americans remember Safire, if they remember him at all, as the Nixon-era speechwriter who evolved into an early, and longtime, con-

servative op-ed columnist for the *New York Times.* But he was also a fiction writer, producing in 1987 what he called "a novel of Abraham Lincoln and the Civil War" that, its publicists enthused, "plunges the reader into the reality and drama of the American Civil War."[2]

That claim remains open to both literary and historical debate. But while the weighty volume consumed more than 1,000 pages, the novel itself came in at "only" 974 pages. It was followed by a so-called underbook of "Sources and Commentary" that ran another 135 pages in small print—a reflection, its dust jacket proclaimed, of the novelist's eight years of research. In fact, Safire exposed, but did not quite solve, an important mystery in his underbook: did significant numbers of Americans know, in advance of its public release on September 22, 1862, that Abraham Lincoln was poised to issue the Emancipation Proclamation?[3] It was Safire's claim that emancipation was an open secret in wartime Washington as early as the summer of that year. If he is correct, how did what columnist Safire might have called "information creep" inflect the actions that Lincoln took leading up to its formal publication? And how should the wider issue of broad foreknowledge—admittedly itself an "underbook" to the wider issue of freedom itself, yet one long overdue for investigation and interpretation—impact our understanding of Lincoln's sincerity as a liberator?

Simply put, if we shine the spotlight on advance knowledge, we might illuminate precisely what Lincoln meant his proclamation to accomplish: whether he was pushed into issuing it, and whether he was deft or clumsy in the ways he prepared an essentially resistant, if not racist, nation for its society-altering impact. How ardently did he tether emancipation to colonization and to proposals for the compensated emancipation of slaves in Upper South states still loyal to the Union? And finally, how should a better understanding of Lincoln's tactics in releasing or withholding information about his impending announcement—or perhaps his doing a bit of both simultaneously—affect his admittedly fraying modern reputation as a liberator?

Interregnum is the archaic word that, where Lincoln is concerned, is most often applied to the four-month secession winter that separated his November 1860 election from his March 1861 inauguration—one of the most perilous periods in American history. But the Union endured a second, equally dangerous two-month interregnum just a year later, between the day Lincoln first read a proposed proclamation to his cabinet and the day he issued a revised and expanded version to the public. (In both cases, Lincoln took pains to say little to the public.) The first draft was revealed on July 22, 1862.

The second was released sixty days later, on September 22. Midway between those two milestones, on August 22, Lincoln wrote a justly famous letter to New York editor Horace Greeley to defend his seeming inaction on and indifference to slavery. Its candor and purpose have been debated and dissected ever since, but rarely subjected to the question of whether some of the public and press—including Greeley himself—might have known at the time that a proclamation was imminent.

Historian John Stauffer has intriguingly posited that Lincoln chose the twenty-second day of each of these three successive months for these historic initiatives with an eye on channeling the memory of George Washington. Washington was of course born on the twenty-second, 130 Februaries earlier, and Stauffer suggests that Lincoln may have subtly hoped that his declaration of independence for slaves might be received as a second American revolution to complete the unfinished work of the first.[4] It is certainly possible. After all, Lincoln, who had once regarded the father of his country as incomparable—"the mightiest name on earth," he said in 1842—had begun his inaugural journey nineteen years later by claiming that he faced a task "greater than that which rested upon Washington" and asking for the guidance of "that divine being, whoever attended *him*" (emphasis added). This was an astonishingly audacious claim for the time. Apparently the widening sectional

crisis had convinced Lincoln that he shared with Washington a special relationship with both history and heaven.[5] The following year, Lincoln ordered Washington's Birthday to be observed with a "general movement" of all armies and navies and, on the home front, by public readings of Washington's Farewell Address.[6] Both well-intentioned ideas proved disasters. Winter weather not surprisingly kept the troops in camp, and when one overzealous citizen rose in the galleries of Congress to perform an uninvited recitation of the Farewell Address, guards had to forcibly remove him. Lincoln was embarrassed enough to pay his fine, explaining that the man was merely trying to perform his "official duty." But after that February in the year of emancipation, 1862, the name of Washington vanished from Lincoln's political vocabulary entirely; he seldom mentioned his name publicly again. Whether Stauffer's ingenious speculation is consistent with this sudden change in Lincoln's attitude I will leave for a bit later.

Lincoln declared that he faced a greater task than Washington toward the end of that first interregnum of 1860–1861. To fully understand the emancipation interregnum requires us to examine not only Lincoln's own growing sense of destiny but also his specific strategy—and in this regard, not only the widely discussed Horace Greeley letter as an indication of his intent but the public's foreknowledge as well. In addition, it requires us to

parse the two other major statements he issued during this tense American summer: comments to a delegation of white men from Chicago, and those to a delegation of black men from the District of Columbia, both of which visited Lincoln at the White House to discuss not only the urgent need for emancipation but also the potential impact of black freedom on white America. Did the widely reported results of these meetings reflect Lincoln's true views on race, or did they mask the full breadth of his ambitions as a liberator while further lifting the thin veil that prevented confirmation of a policy that many Americans believed imminent anyway? Or did the statements, alternatively timid and cruel, accurately define the limited scope of Lincoln's philanthropy? Crucially, what other important events at the time may have influenced or at least explained Lincoln's seemingly inconsistent expressions and tactics, and how did he work to either nurture or deflect public comprehension of these shifts? Finally, what did public silence and selected leaks add to or detract from this complex puzzle?

Any new analysis naturally requires us to discard modern logic whenever discussing the comparatively antiquated approach Lincoln applied to what today we call public relations. While modern chief executives boast White House staffs overflowing with media specialists, Lincoln employed no professional image handlers, no press secretary to issue trial balloons or float well-planned

leaks, and certainly no pollsters to gauge public reaction to policy initiatives in advance. The technology did not yet exist to move information nearly as quickly as it races through the World Wide Web today. Lincoln lacked the advantage—or peril—of blogs, tweets, and Facebook posts to invite mass approval or incite mass dissension. Rush Limbaugh, Sean Hannity, and Glenn Beck were not working on a daily basis to demonize Abraham Lincoln as a radical, nor was Rachel Maddow on the tube every night to complain that he was not more so. Lincoln had the comparatively benign anti-abolitionist conservatives Manton Marble of the *New York World* and James C. Welling of the *Washington National Intelligencer* to assail him in the press as a closet abolitionist, and abolitionists Frederick Douglass and William Lloyd Garrison to paint him as a conservative and a racist.

That said, politicians and journalists of the mid-nineteenth century surely believed they operated within a thoroughly modern communications culture, too, in which new technologies such as the telegraph made it possible to transmit news within minutes and cause it to be published in the press overnight. Slow as the process seems to those of us who dwell in today's personal-device generation, the Lincoln-era media's ability to instigate and spread speculative stories must have seemed equally breathtaking.

Lincoln contributed an abundant personal arsenal of political cunning, a remarkable sense of political timing, a talent for great writing when he believed the occasion called for it, and a dazzling command of the press in an era in which most of the nation's journals were consistently and openly loyal to one political party or the other. However primitive what we might call today the era's "media platforms," Lincoln certainly knew the terrain and how to dominate it. And while he tended to plan in solitary until he was ready to act publicly, he knew how to rally loyal editors and politicians to his side and, conversely, how and when to keep them in the dark. How many he took into his confidence on emancipation, and precisely when he did so, are the questions for today.

The primary challenge to logic here may be the fundamental implausibility of the idea of keeping a secret of any kind—particularly a big secret—in the whirlwind of gossip and speculation, then as well as now, called Washington, D.C. In truth, it was as difficult for official Washington to keep confidences during the Civil War as it has been in modern times in the case of, say, whether or not Hillary Rodham Clinton was to be offered the job of secretary of state in late 2008.

The latter case is actually quite instructive. Many people thought her appointment should happen, while a number of people wanted to prevent it from happening, so ultimately a trial balloon wafted through Washington

(and, typical of twenty-first-century leaks, through social media, television, and the blogosphere), long enough to make the appointment of the president-elect's onetime rival immutable and unsurprising, if not universally popular.

Neither his contemporaries nor his biographers agree on precisely when Abraham Lincoln first shared with others his plan to issue an executive proclamation to strike at slavery. Certainly by the spring and early summer of 1862 he had set the table, commencing to issue a series of veiled albeit mixed messages about his future plans. Biographers tend to skip over the entire interregnum from July to September without exploring how much, if anything, his intimates and the public at large learned during this period. Lincoln in fact labored selectively to define, shroud, or share his intentions during those sixty critical days, not so much amid the news blackout ascribed to it by history as with purposely inconsistent statements and actions designed to broaden support for it. These feints have earned for Lincoln a reputation for cunning, insensitivity, and insecurity.

But Lincoln's bumpy road to emancipation was likely paved not by political guile alone but also by political weakness, at most uncertainty: fear of disappointing both liberals and conservatives, abolitionists and pro-slavery Unionists, Republicans and Democrats, civilians and soldiers, Northerners and Southerners, the thrones and

parliaments of Europe and the Congress and voters of what was left of the United States, and all during a critical election year. Whipsawed by events and contingencies that season, Lincoln had little choice but to send the public mixed messages about administration policy, sharing his secret with those who could help him advance the cause of freedom even if they did not quite know they had become co-conspirators.

Critics often condemn Lincoln for waiting as long as he did to issue his Emancipation Proclamation, but at the beginning of summer 1862 he had good reason to doubt that he possessed either the public or official support, the military power, or the political opportunity to embark on any broad new anti-slavery policy without risking political ruin. Obfuscation became not only a tactic but a life preserver.

On one hand, he had recently accepted the resignation of Major General John C. Frémont, whose own precipitous order confiscating slaves within his military department Lincoln had overturned earlier in the year, claiming that he alone had the power and responsibility to deal with the slavery issue. Yet two weeks later, seeking to redefine the debate, Lincoln called together delegations of Union slave state representatives to push with new urgency a plan for compensated emancipation he had first proposed back in March. (He also signed the long-overdue law ending slavery in the District of

Columbia, ending at last the incomprehensible anomaly that permitted slavery to exist in the capital of the United States until the second year of a pro-slavery rebellion against the government.)

That Lincoln believed in the concept of free labor for his entire adult life is beyond dispute. That he acted cautiously on freedom once in power is also undeniable. Both predilections were apparent when he pushed for compensated emancipation in the Union states, believing that adoption would doom slavery in the Confederate states without direct executive action on his part. Though Lincoln is known as a master of rhetoric, his policy inclinations could often be practical and uninspiring as they slowly materialized. When, for example, one of his most dependable allies in the press, Henry J. Raymond, editor of the *New York Times,* fretted that paying for compensated emancipation would bankrupt the country, Lincoln used economic logic, not humanitarian zeal, to win over the rather conservative journalist. "Have you noticed the facts," he wrote Raymond on March 9, "that less than one half-day's cost of this war would pay for all the slaves in Delaware, at four hundred dollars per head?—that eighty-seven days cost of this war would pay for all in Delaware, Maryland, District of Columbia, Kentucky, and Missouri at the same price?"[7] Here was the precision of an accountant, not the enthusi-

asm of the liberator. "Please look at these things," he implored Raymond, "and consider whether there should not be another article in the Times."

Confident that his policy made economic as well as moral sense, Lincoln summoned the congressional delegations from those states, plus Tennessee and western Virginia, to the White House on July 12, and read a formal statement pressing the point. "I do not speak of emancipation *at once*," he pointed out, "but of a *decision* at once to emancipate *gradually*." Acknowledging—in the form of a warning—the growing power of the forces for freedom, he added: "The pressure, in this direction, is still upon me, and is increasing. By conceding what I now ask, you can relieve me, and much more, can relieve the country, in this important point." Destiny, he insisted in a clumsy attempt, was at eloquence on the side of liberty:

> Our common country is in great peril, demanding the loftiest views, and boldest action to bring it speedy relief. Once relieved, it's [*sic*] form of government is saved to the world; it's beloved history, and cherished memories, are vindicated; and it's happy future fully assured, and rendered inconceivably grand. To you, more than to any others, the previlege [*sic*] is given, to assure that happiness, and swell that grandeur, and to link your own names therewith forever.[8]

His appeal fell on profoundly deaf ears. Following a "stormy" caucus, the delegates of the Union slave states voted 20–9 to reject Lincoln's proposal, dismissing it as economically, socially, and militarily unacceptable.[9] Any form of emancipation, the majority insisted, would not shorten the war, as Lincoln argued, but actually lengthen it since the military would neither support nor enforce it. Not for five months more would Lincoln attempt again to use eloquence to sway Congress on freedom.

By this time, the pro-Union but anti-abolition general George B. McClellan should have forfeited the right of the conservative wing of the federal military to fight exclusively for restoration of the status quo antebellum, half slave and half free. Military progress, or lack of it, would impact Lincoln's freedom strategy throughout the year. And now McClellan's elaborate springtime march along the Virginia peninsula toward Richmond was bogged down in stalemate. With the Confederate capital apparently safe from conquest, Lincoln finally felt emboldened to turn to alternative strategies to break the logjam. Even as McClellan's forces began their last stand at the doomed Seven Days battles, the president traveled secretly to West Point to confer with the veteran military man whom McClellan had earlier ousted as head of the army: Winfield Scott. Did Lincoln confide to the doddering hero that he was contemplating a bold move against slavery? No one knows, but as he was only days away from

finalizing the strategy, it may well be that the loyal old Virginian became, on the fateful day of June 24, 1862, the first official to learn that the president was about to change direction on slavery.

That is, unless one believes the claims of Vice President Hannibal Hamlin. Although Lincoln and his 1860 Republican running mate had developed a bond during the secession winter, meeting to discuss cabinet choices in Chicago two weeks after the election, then sharing the inaugural train between New York and Harrisburg the following February, long-standing tradition triumphed over budding friendship once they took office. In those days, vice presidents did not occupy executive quarters in the White House; they assumed the exclusively legislative role defined by the Constitution, presiding over the Senate and waiting there for a tie vote or a presidential death to make history. Hamlin never attended a single cabinet meeting and, according to the records of Lincoln's daily activities, had no face-to-face meetings with Lincoln between inauguration day and emancipation summer eighteen months later.[10]

But Hamlin later insisted that on the night of June 18, 1862—a full week before the West Point trip and four weeks before Lincoln called his cabinet together to reveal his plans—he visited the White House merely to tell the president that he planned to return to his native Maine for a summer vacation. Lincoln allegedly smiled

at him and coyly replied: "No, you don't intend to do anything of the sort." To which Hamlin, thinking it was one of the president's famous jests, innocently answered: "Oh yes, but I do." "No," Lincoln ordered, "you do not intend anything of the sort; in fact, Mr. Vice-President, you will not leave Washington at present." Finally Hamlin got it. "You are commander-in-chief, so if you wish otherwise . . . I am under orders."

That night, Lincoln ordered Hamlin to accompany him by horseback to the presidential summer retreat at the Soldiers' Home north of the city, and there they had supper, or maybe tea, together. Then Lincoln locked his library door and solemnly announced:

> Mr. Hamlin, you have been repeatedly urging me to issue a proclamation of emancipation freeing the slaves. I have concluded to yield to your advice in the matter and that of other friends,—at the same time, as I may say, following my own judgment. Now listen to me while I read this paper. We will correct it together as I go on.

Then Lincoln opened a drawer, took out a sheaf of foolscap, and began to read aloud. The vice president offered no criticisms at all, but claimed that when pressed further, he offered three suggestions he never specified, two of which Lincoln adopted.[11] (On another occasion, Hamlin suggested that Lincoln had been so

eager to reveal its contents to him that he took it from his coat pocket and recited it aloud while they were driving to the Soldiers' Home.)[12]

What do we make of this claim? It is important to know that it was first published seventeen long years after the event, fourteen after Lincoln's death, and then consecrated in a biography published eight years after Hamlin's death by an understandably biased biographer with a vested interest in gilding the lily: Hamlin's own grandson. Both accounts invite us to believe that Lincoln dramatically directed Hamlin to remain in Washington and await the historic event. Then why did the vice president notify the Senate the very next morning that he was leaving town anyway? In fact, he arrived in Bangor on June 21 and was still there when the proclamation was issued in September, reduced to sending Lincoln a letter of congratulations that praised the order as a "great and noble act" but failed to mention his pride in having supposedly been consulted so early about its text.[13] Yet Hamlin insisted to a Boston reporter a few years before his own death, "I was the first person he ever showed the proclamation to," even as he admitted he had become a person of limited influence by this time. He got along well enough with the president ("anybody could get along with him," he said)—but law and custom made the vice president, he noted, little more than "a contingent somebody."[14] He would become a

nobody soon enough, after Republicans—maybe Lincoln himself—dropped him from the 1864 ticket. Claiming falsely, after Lincoln was no longer alive to dispute him, that he knew about and influenced emancipation would have offered Hamlin sweet revenge for being exiled from the administration. But in fact, he had returned to the Senate representing Maine, finishing his career as a distinguished elder statesman, and never showed either regret or rancor over the chance he missed to succeed Lincoln after the assassination.

No doubt, beyond the bit of self-aggrandizing recollection, there resides an element of truth. Hamlin was zealously anti-slavery—had been "accused," if that is the right word, of being himself of mixed blood. He certainly did favor emancipation—"I was always more radical than he [Lincoln] was," he later boasted with some justification—and if Hamlin was indeed about to head off to remote Maine, it seems plausible that Lincoln would have given him an early warning about his plans. It was probably no coincidence that by mid-June Lincoln had shared his secret with two figures who, despite obvious differences, had much in common: they were both geographically isolated, one at West Point, the other at Bangor, and each, though once prominent either militarily or politically, was past his prime in terms of influence and power. In short, Scott and Hamlin were ideal sounding boards for the formative policy of emancipation. They proved the first of many.

However deficient as a commander, McClellan repre-
sented a far greater risk. Though unsuccessful on the
Virginia Peninsula, the charismatic general remained
popular enough with his underutilized troops to worry
Lincoln deeply. He was a Democrat in politics. Yet
while historians have not noticed, it is likely that Lin-
coln confided in him as well. Two weeks after the
Hamlin affair, unlike the stagnant Union Army, Lin-
coln went on the march again himself, this time to the
headquarters of the Army of the Potomac in Harrison's
Landing, Virginia. There he enjoyed loud and enthu-
siastic demonstrations of his own popularity with the
troops, who cheered him robustly at military reviews.
Getting out of Washington and receiving such support
must have buoyed his spirits and steeled his nerve. But if
a reminder of the perils of a pro-freedom policy was
necessary, he also received a forceful if outrageous
warning from McClellan. A few weeks earlier, when Mas-
sachusetts senator Charles Sumner had pressed Lincoln
on emancipation, the president had confided: "I would
do it if I were not afraid that half the officers would fling
down their arms and four more states would rise."[15] Now
the most prominent of all such officers handed his com-
mander in chief a peremptory, insubordinate letter
proclaiming that "military power should not be allowed
to interfere with the relations of servitude, either by
supporting or impairing the authority of the master,"
and warning that "a declaration of radical views,

27

especially upon slavery, will rapidly disintegrate our present Armies."

The letter clearly implied the threat that McClellan would use his army to restore federal authority, but not to free slaves. Lincoln read it in the general's presence, and though he offered no comment then and there, he must have at least hinted that he intended to ignore the general's advice. We know this because McClellan quickly confided to his wife that he "did not like the Presdt's manner" that day, worrying that "it seemed that of a man about to do something of which he was much ashamed."[16] Notwithstanding his insolence, McClellan had probably become the third person to know something of emancipation before the fact.

En route home from the front, Lincoln's boat briefly ran aground on the Kettle Shoals of the Potomac River—a metaphor for paralysis if ever there was one—and the president took the opportunity to dive into the Potomac for a rare swim, replacing one symbol with another that suggested the casting off of accumulated layers of resistance to change.[17] In more practical terms, it was the middle of a torrid Washington summer, and thank goodness for those shoals: these men seldom bathed, so the opportunity must have offered relief in more than one sense of the word. The very next morning, an obviously refreshed president boldly and deftly eliminated McClellan as a potential obstacle to emancipation by appointing

Henry W. Halleck as general in chief of all land armies of the United States, with McClellan now his subordinate.

Lincoln had reached a decision on another initiative as well. Not long thereafter, he confided his new plans to a fourth and even more unlikely confidant: the pro-Union Mississippian Robert J. Walker, not only a former U.S. senator from the Deep South but a onetime secretary of the treasury under Democratic president James Knox Polk, whose Mexican War policies Lincoln had bitterly opposed while serving in the U.S. Congress. According to Walker, McClellan's peremptory objections to so-called radical views on slavery had "no other result than to make Lincoln think more and more seriously upon the subject; and on his return he said to me, 'We are beaten—we must change our tactics. I think the time has about come to strike that blow against slavery.'" Two days later, Walker claimed, Lincoln "handed me his first draft of an Emancipation Proclamation. There was not a word or a line to alter, and I suggested it being at once submitted to the Cabinet, and published to the country."[18]

Then on July 13—just one day before the border state congressmen overwhelmingly but unsurprisingly rejected his plan for compensated emancipation—Lincoln brought yet more people into the exclusive but expanding loop. During an emotional, rain-swept funeral procession for Secretary of War Stanton's young son—another event

fraught with portentous meaning—Lincoln suddenly turned to his distinguished fellow passengers, Secretary of State William H. Seward and Secretary of the Navy Gideon Welles, and shared a confidence that even the inscrutable Seward confessed was "momentous." Describing himself as "earnest in the conviction that something must be done" to counter "the reverses before Richmond, and the formidable power and dimensions of the insurrection," Lincoln proposed that the time had finally come for "extraordinary measures to preserve the national existence." It was then, Welles remembered, that Lincoln "first mentioned to Mr. Seward and myself"—and, he believed, "to any one"—"the subject of emancipating the slaves by proclamation in case the Rebels did not cease to persist in their war on the Government and the Union, of which he saw no evidence." For the record, both Seward and Welles reacted by expressing misgivings, the conservative navy secretary particularly shocked that such a policy could be proposed by a president who "had been prompt and emphatic in denouncing any interference by the General Government" on slavery.[19]

Again, to put this revelation in chronological perspective within a calendar crowded with incident: this was July 13, three days after Lincoln's return from his visit to McClellan's army and his bracing bath in the Potomac, one day after he had appealed to the border state officials for compensated emancipation, and

one day before they would turn him down. Nine days more would pass before Lincoln revealed his purpose to his own cabinet, yet as many as six people, not including his own staff and family, already knew in advance: two conservative military men, the vacationing vice president, one Southern Democrat, and two cabinet officials.

Frustration over military failure was not the only force propelling Lincoln forward. An ever more aggressively anti-slavery Congress had just passed and sent to him for his approval a sweeping new Confiscation Act giving military officers the right to seize slave property as they advanced into the Confederacy. Lincoln immediately recognized the legislation as a milestone, though he believed it deficient, since it left enforcement to the courts in geographic areas where the federal bench had ceased to operate and where the local judiciary was pledged to a Confederate constitution based on the perpetual legality of slavery. Not surprisingly, abolitionist purists such as William Lloyd Garrison and Wendell Phillips derided the Confiscation Act as woefully inadequate to the crisis, while Thaddeus Stevens dismissed it as "the most diluted milk-and-water gruel proposition that was ever given to the American nation." But conservatives assailed it just as vehemently, warning it would provoke border states out of the fragile Union. Urging a veto, pamphleteer Anna Ella Carroll told Lincoln

that approval would bring on "the end of the republic." Both sides would claim political logic on their side.[20]

Those who saw Lincoln during these tense days found him, as did his old Illinois friend Senator Orville H. Browning, "weary, care-worn and troubled." His onetime law colleague Henry Clay Whitney described him that same day as "haggard and dejected ... frightful to behold."[21] Suddenly worried about his own mortality, Lincoln blurted out, "Browning, I must die sometime," a confession that reduced both men to tears.[22] But, friendship aside, Browning worked on the other side of Pennsylvania Avenue—and it seems clear that Lincoln was yet unwilling to share his decision about emancipation with anyone in the legislative branch, especially unpredictable men such as Browning, who had voted for the First Confiscation Act but opposed the second and strongly advised Lincoln against emancipation.[23] Lincoln knew exactly whom to confide in—and whom to exclude.

On July 17, the pro-administration *New York Times* advised its readers: "It seems not improbable that the President considers the time near at hand when slavery must go to the wall." That day, an exhausted and still uncertain Lincoln traveled up to Capitol Hill, as was customary for presidents on the last day of congressional sessions. There he infuriated both conservatives and liberals alike (further confusing the public about his own intentions) by signing the bill but submitting a lengthy

commentary objecting to what he called the "startling" idea "that congress can free a slave within a state."[24] The emancipation power remained a privilege, as he had once told Frémont, that Lincoln wanted to reserve exclusively to himself. Now, steeled by the advice or reaction of a handful of odd and disparate confidants, and despite unresolved opposition within civilian and military populations alike, Lincoln was ready to deflect Congress and move boldly on his own. He would "not conserve slavery much longer," his secretary John Hay confided to a prominent anti-slavery activist on July 20, confirming what the *Times* had published three days earlier. "When next he speaks in relation to this defiant and ungrateful villainy it will be with no uncertain sound."[25] The very next day, Lincoln prepared to unleash that sound with a force he knew would be heard around the world.

On July 21, with Congress safely in recess—a period when Lincoln seemed to enjoy acting on his own (a year earlier he had used recess to do nothing less than call for volunteer troops, impose a naval blockade, and suspend habeas corpus)—the president convened a cabinet meeting to announce his intention to invoke his power as commander in chief to free slaves in rebel territory as a military measure. As it transpired, that potentially historic meeting bogged down over other issues, and Lincoln adjourned the session until the following morning without revealing his plan. Thus quite by

chance, notwithstanding the irresistible appeal of a Washington's Birthday connection, it was not until July 22 that he read aloud the brief first draft of a proclamation based almost entirely on the recently signed Confiscation Act. It did end with the unmistakable promise that "as a fit and necessary military measure" for restoring "the constitutional relation between the general government, and each, and all the states," "on the first day of January in the year of Our Lord one thousand, eight hundred and sixty[-]three, all persons held as slaves within any state or states, wherein the constitutional authority of the United States shall not then be practically recognized, submitted to, and maintained, shall then, thenceforward, and forever, be free."[26] Lincoln did not follow custom that day by asking his ministers' assent. As he remembered it: "I said to the Cabinet that I had resolved upon this step, and had not called them together to ask their advice, but to lay the subject matter of a proclamation before them."[27]

July 22 might have been remembered as an epochal holy day except for what happened next. Not only did the conservative attorney general Edward Bates of slaveholding Missouri object strenuously on legal grounds, but Postmaster General Montgomery Blair of slaveholding Maryland brought up the political risk, warning (accurately, as it turned out) that the proclamation "would cost the Administration the fall elections."[28] Yet

Lincoln did not back down even when the progressive secretary of the treasury, Salmon P. Chase, declared that he preferred simply giving generals in the field the power "to organize and arm the slaves" themselves.[29] Emancipation faltered as frustratingly as McClellan's army that morning only when Secretary of State Seward warned that so radical a step in the wake of recent military reverses would "be viewed as the last measure of an exhausted government, a cry for help . . . our last *shriek*, on the retreat." It was "an aspect of the case," Lincoln later admitted, that he had "entirely overlooked." In response, as he later told an artist who subsequently painted that rather pre-climactic session, "I put the draft of the proclamation aside, as you do your sketch for a picture, waiting for a victory."[30]

It proved a longer wait for this consummate political artist than Lincoln had feared in his worst nightmares, with emancipation now hinged irrevocably to a military triumph that might never come. And with the order postponed indefinitely and now known to the most important officials in Washington, the circle of insiders privy to its inevitability, now fifteen strong with the cabinet and his clerks included, soon slowly, surely, and purposely expanded. For the president, sharing the secret became a pillar of a new three-tiered strategy, only a portion of which the public ever fully understood.

First, Lincoln committed himself to modifying his spare original draft proclamation to close legal loopholes and perhaps embrace progressive aspirations on black enlistment. "From time to time," he recalled, "I added or changed a line, touching it up here and there, anxiously watching the progress of events."[31]

Second, he began working concurrently to prepare the nation for what he hoped would be an imminent policy revolution, aware it would mark the first time in world history that any nation had attempted to redefine its war aims in the midst of the conflict, and aware it would upend race relations in America forever.

And third, he labored to manage and benefit from what must then have seemed a reasonable expectation that news of emancipation would find its way to the public before Union armies won the kind of military victory Lincoln now agreed must precede its official announcement.

Waiting anxiously for victory to trigger emancipation, Lincoln instead would endure yet another crushing defeat: the unmitigated Union disaster at the Second Battle of Bull Run at the end of August, a setback that might have tempted a less determined liberator to shelve the initiative altogether. Instead, it propelled Lincoln to continue what had become an elaborate outpouring of disinformation: preparatory rhetoric that emboldened freedom expectation among anti-slavery progressives

without igniting potentially fatal opposition from conservative Northern Democrats and, worse, disunion among pro-slavery border states. That such a balancing act could have succeeded without collapsing of its own weighty inconsistency for two long months constitutes perhaps the most amazing backstory of all. What Lincoln allowed the public to know—and when—served, however fitfully, imperfectly, even insultingly, to prepare the country's white majority for black freedom even as it has served since to sully Lincoln's reputation as an emancipator.

Certainly the hints came as quickly as the leaks. To his emissary to Union-occupied Louisiana, Reverdy Johnson, he wrote on July 26: "I must save this government if possible. What I *cannot* do, of course I *will* not do; but it may as well be understood, once for all, that I shall not surrender this game leaving any available card unplayed." And two days later he told a New Orleans loyalist: "What would you do in my position? Would you drop the war where it is . . . prosecute it in future with elder-stalk squirts charged with rose water? Would you deal lighter blows rather than heavier ones? Would you give up the contest leaving any available means unapplied?"[32] Lincoln's White House secretaries understood that, however "persistently misconstrued," their boss's words at this time were meant to accomplish but one goal: "to curb and restrain the impatience of zealots from either faction."[33]

On August 14, in perhaps the most infamous example of encouraging people to misconstrue him, Lincoln hosted what was called a "Deputation of Free Negroes" at the White House. Lost to history now is the fact that no American president had ever before invited a group of African Americans to confer with him officially. Of course, the encounter quickly descended into something less than a conference. After clumsily asking his visitors whether they were indeed free—in fact, they were rather prominent and influential—Lincoln launched into a frosty, patronizing lecture to the stunned delegation, conceding that "your race suffer very greatly . . . many of them by living among us," but adding that "ours suffer from your presence. In a word we suffer on each side. If this is admitted, it affords a reason at least why we should be separated." Lincoln's words were harsh and stinging:

> The aspiration of men is to enjoy equality with the best when free, but on this broad continent, not a single man of your race is made the equal of a single man of ours. Go where you are treated the best, and the ban is still upon you. . . . It is better for us both, therefore, to be separated.[34]

Lincoln's proposed solution was voluntary colonization to Liberia or perhaps, in a halfhearted concession that black people might want to "remain within reach

of the country of your nativity," to Central America. Though the administration now had a $600,000 budget with which to begin evacuation and relocation, and though political affairs in Central America were admittedly chaotic, Lincoln persisted that emigration was still worth what he called a "try," and offered to "spend some of the money intrusted to me." Conceding that such a momentous decision ordinarily would require at least "a month's study," he nonetheless wanted an immediate commitment. Though he had all but ceased invoking Washington's name to consecrate his own policies, Lincoln tried to justify his colonization initiative by offering an audacious reference to his famous predecessor. Ignoring the well-known fact that Washington had been a slaveholder, Lincoln urged his well-situated African American visitors, all established residents of the capital, to "sacrifice something of your present comfort for the purpose of being as grand in that respect as the white people." After all, he argued with almost breathtaking insensitivity, "Gen. Washington himself endured greater physical hardships than if he had remained a British subject. Yet he was a happy man, because he was engaged in benefiting his race. . . ."[35]

It probably came as no great surprise to Lincoln that his blunt speech ended up making absolutely no headway in convincing African Americans to abandon America, although he may well have been stunned by the

depth and hostility it elicited from the black community beyond Washington. Although delegation chairman E. M. Thomas politely wrote afterward to assure the president that "when the subject is explained," freedmen would "join heartily in sustaining such a movement," it soon became evident that most black leaders thought Thomas had overstepped his authority merely in agreeing to the meeting, much less endorsing the president's proposal.[36] Poet Frances Ellen Watkins Harper spoke for many African Americans when she likened Lincoln's statement to "the idea of a man almost dying with a loathsome cancer, and busying himself about having his hair trimmed according to the latest fashion."[37] And as historian Eric Foner has pointed out, a "heedless" Lincoln failed to appreciate that his words might fuel a wave of violent racism in the country aimed at African Americans.[38]

Frederick Douglass, who had two weeks earlier told an Independence Day crowd that Lincoln's actions to date had been "calculated in a marked and decided way to shield and protect slavery," reacted to the White House lecture with fury. He charged the president with illogically and unfairly using "the language and arguments of an itinerant Colonization lecturer, showing all his inconsistencies, his pride of race and blood, his contempt for Negroes and his canting hypocrisy." With his ill-chosen words, Douglass fumed, Lincoln had fur-

nished "a weapon to all the ignorant and base, who need only the countenance of men in authority to commit all kinds of violence and outrage upon the colored people of the country." As Douglass pointed out, slavery had caused the war, not slaves:

> Mr. President, it is not the innocent horse that makes the horse thief, not the traveler's purse that makes the highway robber, and it is not the presence of the Negro that causes this foul and unnatural war, but the cruel and brutal cupidity of those who wish to possess horses, money, and Negroes by means of theft, robbery, and rebellion.[39]

Douglass was of course right both philosophically and morally. But he was naive in terms of the white politics involved. For better or for worse, Lincoln had scant interest in what the African American press or, for that matter, the broader African American community thought of his stunt. And that was because it had been aimed at precisely the audience he had not invited to the White House that day: not free and aspiring blacks but free and fearful whites. Historians have focused too much attention on what Lincoln's lecture revealed of his purported racism or his longtime but soon-to-be-discarded interest in colonization. While the modern reader shudders as Douglass once did at Lincoln's

heartless words, we might be more profitably engaged in examining the incident within the broader context of public relations as well as military strategy, the latter of which is almost never discussed.

The same day as he met the delegation of freedmen, Lincoln likely read a letter from Senator Browning reporting from their common home state of Illinois that the president seemed so *"strong among the people"* he could safely "do anything which your full and unbiased judgment shall decree necessary to give success to our arms, and crush the rebellion." Between the lines, by the way, this letter implied that Browning had finally been taken into Lincoln's confidence, too—once he had left the capital. "The only grumblers," the senator suggested, "are a few radicals of the [New York] Tribune persuasion, and a few other radicals of the pro slavery school—the latter, dissatisfied because the war is not solely for the protection of slavery, the former because it is not solely for its extermination."[40] While the report undoubtedly reassured Lincoln that he remained popular at home, it was principally because he had not acted against slavery, thus reminding him that he still needed to make his case to moderates. Excluding pro-freedom whites—and even long-suffering blacks themselves—from the discussion, Lincoln had maladroitly appealed to the baser instincts of his constituency. Salmon P. Chase spoke for many disappointed progressives when he recorded his

disillusionment in his diary: "How much better would be a manly protest against prejudice against color!"[41] It was a mistake Lincoln would not make again. In the end, he spent but $38,000 of the $600,000 congressional appropriation for colonization.[42]

More to the point, he had already confided his intention to issue an emancipation proclamation to a small but important circle of intimates. He had made a thrust against slavery in Southern states still loyal to the Union, however tenuously, sincerely believing that if compensated emancipation succeeded, he "would not have lived in vain."[43] He had neutralized some potential political opposition, and army disloyalty, by nudging aside and ultimately firing McClellan. He had signed the Second Confiscation Act, expressing enough doubts about its constitutionality to position his own actions as a remedy. And he had already drafted an actual proclamation and read it to his cabinet. But with the seasoned Blair's political prophecy haunting him, Lincoln believed he must remove his action from the realm of sympathy with actual slaves, or lose so much white support that his action, his administration, and with them the Union itself would all fall.

There were reasons to be guardedly hopeful. McClellan's successor, General John Pope, was by then in the midst of a major offensive in Virginia, and Lincoln surely imagined a decisive victory might occur that could unsheathe the

proclamation at last. Prepared to issue the document exclusively as a military order, a measure of his uncertainty about its reception among Northern Democrats and border state loyalists such as the overwhelmingly anti-freedom legislators who had rejected earlier initiatives, Lincoln clearly meant his White House performance to remind Northern whites that he was no friend of black people. Any action he might take in the days to come would be aimed at securing victory in the war and restoration of the Union, not the controversial liberation and potential amalgamation of millions of slaves.

Harsh? Yes. Politically correct? Hardly. A stain on Lincoln's record? Perhaps. But with fall congressional elections looming, Union sentiment in the North fading, border states now on record as hostile to freedom, and the press maddeningly divided on all of the above, Lincoln probably had no choice. The bitter pill of prejudice, along with the impractical and inhumane concept of colonization, was his choice of emetic for a body politic he believed needed purging in preparation for an act he hoped (with the Army of the Potomac about to engage the Army of Northern Virginia) might only be days away from promulgation. That is why, sensing military victory, Lincoln made sure his harsh speech did not just leak but poured. There is no question that he wanted his message publicized: he had invited journalists to the White House to record every word in order to guar-

antee its wide circulation. He was not disappointed then, even if the episode disappoints us now.

The following week, with the military situation still murky, Horace Greeley of the *Tribune* struck his own blow for freedom, putting the administration on the defensive and testing Lincoln's public relations skills more than ever. In an editorial entitled "The Prayer of Twenty Millions," Greeley charged that the president had been "strangely and disastrously remiss" on the slavery issue, and "unduly influenced" by "fossil politicians" from the border states. Greeley bluntly warned that "all attempts to put down the Rebellion and at the same time uphold its inciting cause"—slavery—were "preposterous and futile." The time had come, Greeley proclaimed, for using the "emancipating provisions of the Confiscation Act."[44]

Lincoln's reply is so famous it hardly needs full repetition. But the substance of his argument was compressed within its best-remembered sentences:

> My paramount object in this struggle *is* to save the Union, and is *not* either to save or destroy slavery. If I could save the Union without freeing *any* slave I would do it, and if I could save it by freeing *all* the slaves I would do it; and if I could save it by freeing some and leaving others alone I would also do that. What I do about slavery and the colored race, I do because I believe it helps to save the Union;

and what I forbear, I forbear because I do *not* believe it would help to save the Union.

Although he added an ameliorating coda—"I have here stated my purpose according to my view of *official* duty; and I intend no modification of my oft-expressed *personal* wish that all men every where could be free"—Lincoln's message was otherwise remarkably consistent with his recent speech to the Washington freedmen.[45] What he did now was expand it ever so subtly, introducing the idea of freeing some slaves if such a policy could win the war and save democracy.

Lincoln's genius for public relations was never in sharper focus. Though crafted as a private letter to a specific editor—it was addressed to Greeley and dutifully printed in his *New York Tribune* on September 25—the president slyly made sure it was first leaked to the often critical Washington newspaper, the *National Intelligencer*, two days earlier. Only then would it be picked up and reprinted by newspapers throughout the country. Greeley would have his response but not his exclusive. Moreover, as *Intelligencer* editor James C. Welling gloated, with the broad release of his "pithy and syllogistic" message Lincoln "proceeded to take the whole country into his confidence." The grateful Welling, who was as close as any editor to Lincoln during the Civil War, fully recognized the genius of Lincoln's strategy:

"The anti-slavery passions of the North, which had hith-
erto been kicking in the traces, were now efficiently yoked
to the war chariot of the President."[46]

For his part, Lincoln remained worried. In a collo-
quial but revealing sentence he had employed before
and now drafted anew for the Greeley letter, only to
wisely cross it out before submitting it for publication,
he observed: "Broken eggs can never be mended." Once
he acted, the president understood, he—and the country—
could never go back. However, even anti-emancipation
journals reacted well to the Union-first tone of the Gree-
ley response, with the usually critical New York *Journal
of Commerce* predicting that the statement would "touch
a response in every American heart." Albany Republican
Thurlow Weed, who still hoped Lincoln would not "di-
vide and destroy the North" with a proclamation against
slavery, conceded that the president's response to Gree-
ley (whom he hated) "warmed the hearts, inspired the
hopes, and touched the patriotism of the people . . . let
whatever strengthens our cause, or weakens the En-
emy, be done."[47] Greeley himself acknowledged with an
undercurrent of jealousy that the "manifesto was exult-
ingly hailed by the less radical portion of his support-
ers," adding, "I never could imagine why."[48]

But there is more even to the Greeley episode than
this, and it speaks directly to the issue of foreknowl-
edge. On August 18, just two days before Greeley published

his editorial, Lincoln's Mississippi confidant Robert J. Walker had returned to the White House with a special guest: novelist James Robert Gilmore, who under the pen name of Edmund Kirke had just published a book of anti-slavery fiction called *Among the Pines*. The novel featured the telling line: "Free the Negroes by an act of emancipation, or confiscation, and the rebellion will crumble to pieces in a day." Walker had earlier sent Lincoln a copy of the book, and Lincoln, who did not ordinarily read novels but thought its author showed he "knew the South,"[49] now wanted to meet its author. Before the presidential audience could even begin, Walker abruptly confided to the novelist: "I have good news for you, but it must be strictly confidential,—the Emancipation Proclamation is decided upon." Gilmore was understandably excited—and was sure his boss would be more so. For the part-time novelist had a full-time job: he worked for the *Tribune* and Horace Greeley.

As Gilmore now loyally argued, "all of Mr. Greeley's impatience would be removed if he knew these facts." But Walker cautioned: "We had better ask Mr. Lincoln. I have suggested it, but he has been fearful Greeley would leak out." The president weighed in with typical ambiguity: "I have only been afraid of Greeley's passion for news. Do you think he will let no intimation of it get into his paper?"[50] No one left a record of how the conversation ended.

Gilmore would later claim that he did not arrive back in New York City until the day Greeley's "Prayer of Twenty Millions" actually hit the presses, but it strains credulity to believe that this loyal employee, or his equally loquacious *Tribune* colleague Sydney H. Gay, who also believed a proclamation was imminent, did not share their advance knowledge of emancipation as soon as they could get to a telegraph. A reasonable circumstantial case can certainly be made that Greeley, who must have been working on his long editorial for days, responded to the tip by accelerating his publishing schedule, not merely to encourage Lincoln to issue an emancipation but also to put himself in the position of earning credit of his own when it was.

But Lincoln had the last laugh. Greeley may have written out his "Prayer" in advance and then rushed it into print in a carpe diem moment, but Lincoln had likely drafted his "paramount object" message earlier as well— and remember that Welles distinctly called it a "message," not a letter—not as a reply to one editor but as a generic justification for emancipation. Then he demonstrated his own agility by quickly reformatting and releasing it in the form of a reply to Greeley once the *Tribune* gave him an opening. A president who had written and patiently pocketed an emancipation proclamation was certainly capable of composing a defense and then withholding it until the perfect moment for its release presented itself.

War correspondent Whitelaw Reid later provided corroboration, claiming that the president read the letter aloud to at least one confidant before Greeley's editorial ever appeared, and Greeley himself also came to believe that "Mr. Lincoln's letter had been prepared before he ever saw 'Prayer,' and that this was merely used by him as an opportunity, an occasion, an excuse, for setting his own altered position—changed not by his volition, but by circumstance—before the country." "I'll forgive him anything," he added ponderously, "if he will issue the proclamation."[51] In one sense, it is hard to judge who proved more disingenuous in this affair: the editor who suspected emancipation was inevitable but publicly demanded it anyway, or a president who had firmly decided to issue a proclamation now contending that he would do so only to restore the Union. The prize may go to Lincoln, for while Greeley's editorial had called on him only to enforce the Confiscation Act, the president replied as if the editor had demanded an executive order. "I do not see," Greeley complained, "how these points can have escaped the attention of any acute and careful observer."[52]

Still trying to win the last trick, Greeley attempted to trump Lincoln one more time, fully armed now with James Gilmore's detailed gossip straight out of the White House. Even before Lincoln could issue his "paramount object" message, the *Tribune* ran a major story on August

22 under the bold headline "From Washington. The Abolition of Slavery. Proclamation of Emancipation by the
President. Part of the Cabinet Oppose It." Reporting that
the paper had learned this breathtaking news "from so
many sources that it can no longer be considered a state
secret," the *Tribune* announced: "Two or three weeks ago
the President laid before his Cabinet a proclamation of
Emancipation abolishing Slavery wherever in the 1st of
next December the Rebellion should not be crushed."
The paper did get some of the supposedly top-secret details wrong—reporting, for example, that the order would
take effect December 1 instead of January 1, and mistaking the cabinet officer who had opposed it. But otherwise it was not only the scoop of the century but
uncannily accurate.

It is little wonder that, armed with such a story, Greeley stubbornly refused to print Lincoln's letter on
August 24, no doubt convinced that his scoop would
render it meaningless. He could not have been more
wrong. Rival papers, typically eager to print other journals' stories, ignored the *Tribune* exclusive entirely and
devoted their attention instead to condemning Greeley's editorial and praising Lincoln's letter. The archrival
New York Times, for example, commented that Lincoln
"could not have said anything more satisfactory to the
country," adding slyly: "It is in infinitely better taste,
too, than the rude epistle to which it is an answer." The

next day the *Times* resumed its condemnatory barrage by charging Greeley with endeavoring "to substitute his own conscience for Mr. Lincoln's in the present National perplexity. The President not yet seeing the propriety of abdicating in behalf of our neighbor, consoles him with a letter that assures the country of abundant sanity in the White House."[53] But not a single rival paper is known to have taken the *Tribune* exclusive seriously enough to reprint it, much less challenge it. As it turned out, Lincoln's clarifying letter served as a response not just to the widely reprinted editorial of the eighteenth but also to the shocking but shunned news flash of the twenty-second. Implicit it may be, but surely no argument can better attest to the widespread and growing expectation that the proclamation might only be days away. It is little wonder that Greeley concluded after the episode: "I can't trust your 'Honest Old Abe.' He is too smart for me."[54] Indeed, the president had out-scooped the veteran journalist.

By August 26, even the more conservative *Times* seemed not only to bow to the inevitability of emancipation but also, despite its frequently stated reservations about black recruitment, to embrace it. "When the proper moment shall arrive for such a step," it editorialized, "we believe the President will take it, and we do not believe he will be coerced into taking it a single day sooner than his own judgment tells him, it can be taken with effect, and made instrumental in preserving the

Union."[55] Within days, however, General John Pope went down to crushing defeat at Second Bull Run, and the moment was lost even if the secret was out. A president less committed to liberty might have retreated from his commitments and folded as quickly as the whipped Army of the Potomac.

Instead, Lincoln brought still more people into the circle of his confidence, while the privileged few began doing no small amount of confiding themselves. The whispers were everywhere, adding to the rising momentum. Around the same time as the Greeley imbroglio, Washington gadfly Adam Gurowski confided to his diary: *"Vulgatior fama est"*—meaning "all over town"—word was spreading

> that Mr. Lincoln was already raising his hand to sign a stirring proclamation on the question of emancipation; that Stanton was upholding the President's arm that it might not grow weak in the performance of sacred duty; that Chase, Bates, and Welles joined Stanton; but that Messrs. Seward and Blair so firmly objected that the President's outstretched hand slowly began to fall back.

This inside report of the July cabinet meeting was as accurate and detailed as that featured in the *Tribune*.[56]

Even earlier in August, the *Chicago Tribune* confidently predicted that a proclamation "will come," and by the end of the month it concluded that "from the

tenor" of Lincoln's Greeley letter, "if the next battle in Virginia results in a decided victory for our army," a proclamation "will be forthwith issued." The Washington *Evening Star,* meanwhile, outlined for the entire capital that it was being whispered in "unusually well-informed circles" that some "direct and decisive action is to be taken in prosecution of the war."[57] The *New York Evening Post* claimed it was "well known that the President had this proclamation ready some weeks" before and would have issued it sooner but for the "shameful" defeat of Union forces at Bull Run. The *New York Times* was convinced by the end of August that "when the proper moment shall arrive for such a step, we believe the President will take it." And even the anti-Republican *New York World* acknowledged that "Proclamation Mania" had overrun the North.[58]

Going these sources one better, Chicago's anti-slavery congressman—and longtime Lincoln loyalist—Isaac Newton Arnold insisted in his own recollections of the Civil War that as early as spring "it was well known at Washington that the President was considering the subject of emancipating the slaves as a war measure." Though acknowledging the pressure against such a move, Arnold added that border state men "were ready to crown him the peer of Washington if he would not touch slavery."[59] Even in the Confederacy, the well-placed diarist Mary Chesnut admitted earlier in the summer: "If

anything can reconcile me to the idea of a horrid failure after all to make good our independence of Yankees, it is Lincoln's proclamation freeing the negroes."[60]

It is difficult to imagine that one of Lincoln's closest press confidants, John Wein Forney of the *Philadelphia Press,* was not brought in on the secret as well. On July 30, his paper published a seemingly critical editorial that essentially amounted to a clumsily written if heartfelt trial balloon for emancipation:

> A million able-bodied men await but our word to ally themselves with us bodily, as they are with us in heart. A magnificent black blister as a counter irritant! . . . Will we use it? Or shall we go on for another year paying bitterly in blood for our culpable irresolution? . . . The cause is too great to permit such namby-pambyism.[61]

But once the army lost at Bull Run, Lincoln had little choice but to resume his program of obfuscation and hints.

Who else knew about the inevitability of the Emancipation Proclamation between July 22 and September 22—or earlier—aside from obvious suspects such as Winfield Scott, Hannibal Hamlin, Robert J. Walker, James Gilmore, Horace Greeley, Henry J. Raymond, and other editors and writers? And what did they contribute to the run-up to the emancipation aside from providing

sounding boards, advice, and competition for credit? The number had now reached at least twenty-three, not even counting the *Tribune*'s claimed national circulation of 200,000. More people were in the know than we have ever suspected, with more significant results than we have heretofore appreciated.

The entire cabinet found out in July. Lincoln's secretaries John Nicolay and John Hay knew, of course, as did everyone else to whom they enjoyed whispering state secrets in Washington's salons. After the aborted July 22 cabinet meeting, Seward certainly confided in his political guru, Albany editor Thurlow Weed, who promptly headed to Washington to lobby Lincoln for delaying emancipation, arguing passionately that "it could not be enforced in the Rebel States—that it would add to the intensity of their hatred, and might occasion serious disaffection to the Union cause in the border states; that it would work no good and probably would do much harm."[62]

Worried about whether emancipation might drive Kentucky from the Union, Lincoln also read the proclamation to his future attorney general, James Speed, who no doubt told his brother Joshua, the closest personal friend Lincoln ever had, though it was years since Lincoln had enjoyed Speed's slave-based Southern hospitality. They had grown apart on the issue of emancipation, with Josh complaining to Lincoln in September of "the

infernal negro" question.[63] His brother was more specific. On July 28 James argued:

> I have pondered over the proclamation, the draft of which you read to me. The more I have thought of it, the more I am satisfied that it will do no good; most probably much harm. The negro cannot be emancipated by proclamation. If the white man does not liberate him under the operation of the laws of political economy, he must share in the dangers that are to be encountered in his liberation. . . . A sweeping proclamation would be idle because impracticable. It would delude the poor negro, and shock most violently the prejudice of many in the north & nearly all in the South.

Speed ended his blunt letter by dismissing abolitionists as "psalm singing philanthropists" and imploring: "Let me beg of you to banish the idea that many northern men believe, that the negro can be set free or benefited by mere paper proclamations. If the negro is to be free he must strike for it himself."[64]

Lincoln obviously disagreed, because he turned to other residents of what he liked to call "the state of my nativity" in search of support. Sending the anti-slavery minister to Russia, Cassius Clay, back home to test the mood of the state legislature for emancipation, Lincoln likely took him into his confidence as well. Clay argued

for acting quickly, which Lincoln typically questioned by worrying that a proclamation might turn the crucial state "against us."[65] "We hope to have God on our side," Lincoln was famously supposed to have said, "but we must have Kentucky." Clay knew Lincoln well enough to comprehend that behind the posturing was the rapid approach of bold new policy.

Charles Sumner, too, believed as early as May 28 that "a decree of Emancipation would be issued within two months," and let slip the source of his growing conviction: Stanton had told him so. By August 12, Chase assured Sumner promisingly that "the President's mind undergoes, I think, a progressive change in the line of a more vigorous policy and more decisive enfranchisement."[66] On August 4, James A. Hamilton, in what he described as a "Circular to the Governors of the Loyal States" and sent at the very least to one of them, New York's Edwin D. Morgan, openly revealed that "a day or two after the adjournment of Congress, such a proclamation as they believed the President ought to issue was prepared and presented to him by several members of his cabinet and other gentlemen," and that Lincoln "approved of the policy thereby indicated, and declared that, with slight modifications, he would issue it. Unhappily for the country," Alexander Hamilton's son reported, "the purpose was frustrated by two members of the Congress." Hamilton suggested that a delegation of

governors proceed at once to the White House and urge Lincoln "to issue a proclamation" immediately.[67] That widened the circle of the informed considerably. By August 16, abolitionist Wendell Phillips told Horace Greeley, "The destruction of slavery is inevitable," though Phillips insisted he lacked confidence in "this *administration.*" Only two weeks earlier, he had complained: "If Mr. Lincoln could only be wakened to the idea . . . that God gives him the thunderbolt of slavery with which to crush the rebellion." As he had told the *Tribune*'s managing editor, Sydney H. Gay, "If the proclamation of Emanc. is possible at any time from Lincoln (which I somewhat doubt) it will be wrung from him only by fear."[68] By then, *Tribune* correspondent Adams Hill knew as well, and told Gay that so did Senator Samuel Pomeroy.[69] Greeley printed Phillips's letter, and might have reacted by hastening the work on his "Prayer of Twenty Millions." As time passed, all these private and public reactions seemed increasingly interdependent.

Around August 20, yet another of the president's loyal Illinois friends, attorney Leonard Swett, happened to visit the White House. The Greeley editorial had just been published and the city was buzzing with speculation about what Lincoln would do next. But as Swett recalled, his old colleague at the bar simply invited him to sit down, explaining: "I want to show you certain documents that I have here." According to Swett, "He

then went and brought out several bundles of letters which he opened and, as was his custom, cheerfully read aloud. First came some *New York Tribune* articles that argued that "the President and all the men in the Administration were a sett [*sic*] of 'wooden heads' who were doing nothing and letting the country go to the dogs. 'Now,' said he, [']that represents one class of sentiment.[']" Next Lincoln read a long paper by Robert Dale Owen arguing that "the people are ready . . . the loyal citizens of the North . . . are today prepared for Emancipation. They feel that the sacrifices they have made, and are making, are too vast to have been incurred except in purchase of a great pledge of perpetual safety and peace."[70] "That is a very able paper indeed," offered Lincoln. "He makes a very strong argument. I have written something on this subject myself," he volunteered. "But it is not so able an argument as this." Before he could show Swett his own composition, the cabinet entered the room for a meeting, and Swett withdrew. "I had intended . . . to have shown you something else," Lincoln said as they parted, "but it has got so late I haven't time now."

That night, Swett thought further about what he had heard and concluded that the unnamed document to which Lincoln had referred "couldn't be anything else than the proclamation itself." He rushed back to the White House the next morning and "hinted" his "sur-

mises" to the president. "In answer he simply said with a significant smile: 'Am I *doing* anything wrong?' I replied 'No, I can't say that you are.' 'Well then,' answered he banteringly, 'get out of here.'"[71] Swett obligingly headed back to Illinois, undoubtedly to win over doubters such as Browning.

Shortly before his death in 1864, the Land of Lincoln's most ardent abolitionist, Congressman Owen Lovejoy, eager to rescue the president from any suspicion that "anti-slavery men from Illinois" had extorted him into issuing the proclamation, told William Lloyd Garrison that he had learned from Lincoln's "own lips" that he "had written the proclamation in the summer, as early as June." Gideon Welles later validated Lovejoy's hint of foreknowledge by asserting: "I have some reason to suppose that Owen Lovejoy, the avowed and leading Abolitionist in Congress, was confidentially consulted."[72]

Others may have been included, too. The once minor party loyalist who had invited Lincoln to speak at Cooper Union back in 1860, arguably launching his presidential candidacy, was one. The president had generously rewarded Hiram Barney with the most lucrative patronage job in the administration, collector of the Port of New York. Barney testified that during a September 5 visit to the White House, the president read aloud to him the latest draft of the proclamation "in his

own hand writing and in his pocket when we were to-gether." That claim was endorsed by Massachusetts senator Henry Wilson, later vice president under Grant, who one must reasonably conclude knew the story as well via Barney if not other sources (bringing the number of insiders to nearly forty, by my count).[73] Two days later, it might be noted, Lincoln's secretary John Hay, a prolific and authorized, if anonymous, contributor to Republican newspapers, blatantly spread the word further with a detailed report in his favorite outlet, the *Missouri Republican:* "Perhaps the time is coming when the President, so long forbearing, so long suffering with the South and the border, will give the word long waited for, which will breathe the life that is needed, the fire that seems extinguished, into the breasts of our men at arms." Hay added a strong defense of Lincoln's recent reticence and mixed messages. The president simply believed that any official "utterances would instantly form an issue . . . which would divide and fiercely fight those who were now most strongly united in the defense of the Union. While the contest could be better carried out without an executive pronunciamento, the President thought best to keep silent."[74]

Lincoln's final, typically mystifying public effort to frame emancipation on his own terms came on September 13, when he welcomed to the White House a three-man delegation representing the diverse Christian

denominations of Chicago. The churchmen had recently sent Lincoln an impassioned "memorial" calling "without delay" for "National Emancipation."[75] The president was eager to reply, having just learned that Confederate forces under Robert E. Lee had invaded Maryland and that the Union Army, once more under McClellan's command, was heading for another confrontation. Once again the military calendar had assumed the leading role in the emancipation drama. Lincoln had every reason to expect a new battle, and every hope that it might at last result in a victory that would trigger release of the proclamation. The contingency no doubt spurred Lincoln to speak out again, just as he had when he issued the so-called Greeley letter in anticipation of a Union victory at Second Bull Run.

Speaking to his three visitors from an armchair at his writing desk, Lincoln began his reply by professing a strong desire to understand God's will as accurately as they might know it. *"And if I can learn what it is,"* he added emphatically, *"I will do it!"* It was a new argument, and it had taken a year and a half for the man who once dared associate himself with the secular saint George Washington to admit a new reliance on an even higher power. But while conceding that slavery was "the root of the rebellion" and that the Rebels would have "been impotent without slavery as their instrument," Lincoln added with undisguised exasperation: "What *good* would a

proclamation of emancipation from me do, especially as we are now situated? I do not want to issue a document that the whole world will see must necessarily be inoperative, like the Pope's bull against the comet!"— a reference to Pope Callixtus III's legendary 1456 order futilely excommunicating Halley's Comet (and a doubly ironic reference because that pope published another bull that year affirming the right of whites to enslave Africans).

"Would *my word* free the slaves," Lincoln continued, "when I cannot even enforce the Constitution in the rebel States?" Besides, he wondered aloud, where would the liberated people go and "what would they do"? Proceeding in this meandering way, he then reiterated the substance of the Greeley letter by adding: "Understand, I raise no objections against it on legal or constitutional grounds; for, as commander-in-chief of the army and navy, in time of war, I suppose I have a right to take any measure which may best subdue the enemy. Nor do I urge objections of a moral nature, in view of the possible consequences of insurrection and massacre at the South. I view the matter as a practical war measure, to be decided upon according to the advantages or disadvantages it may offer to the suppression of the rebellion." After an hour of lively if thoroughly inconsistent discussion, the group departed, assuring Lincoln "that God would reveal the path of duty to the President."[76] Al-

though no reporter was present this time to record the apparently unscripted conversation, the three ministers rushed to write down what they remembered of the president's statement, and later saw to its publication. Back they went to Illinois to tell their congregations that the president would do as God instructed him. Meanwhile, in the earthly sphere, unaware of the political maneuvering on the White House stage or the military movements near Sharpsburg, Maryland, exasperated New York diarist George Templeton Strong wondered whether another battlefield disaster might make Jefferson Davis president instead of Lincoln. "This honest old codger was the last to fall, but he has fallen," moaned Strong. "Nobody believes in him any more. . . . Abe Lincoln is not the style of goods we want just now . . . he is unequal to his place."[77]

The God-fearing message Lincoln had already delivered to the Chicago ministers might have altered those views, but for the fact that it took the visitors ten days to return home and publish their recollections. Historian Mark E. Neely Jr. thus refuses to accept it as evidence of any effective plan to prepare Northerners for emancipation as an act of unavoidable Union-saving military necessity. Neely has a point: of all three public messages, this seemed the most rambling and unfocused, and the least targeted for prompt publication. Moreover, Neely noted that since Lincoln's remarks were not printed in Chicago until September 23, the same day

his actual proclamation appeared in print in the very same newspaper, how can it qualify as good public relations or a carefully planned effort to prepare the Northern public for emancipation?[78] But leaving aside the salient fact that the remarks found their way to print in New York a full week earlier, Neely's argument hinges on the notion that Lincoln knew in advance that Union armies would soon prevail at Antietam. In fact, Second Bull Run had taught the president to anticipate no such victories. For all he knew, Lee's northern invasion would succeed. It was far safer to appeal to popes, comets, and God than to count on McClellan.

However muddled, Lincoln's remarks to the Chicago delegation provide us with the most detailed political analysis of imminent emancipation that he had ever advanced in public. "I will . . . concede," he noted, "that emancipation will help us in Europe" (pointedly using the future tense "will," not the conditional "would") "and convince them that we are incited by something more than ambition," even if it was for the "grand idea" of constitutional government. "I grant further that it would help *somewhat* at the North, though not so much, I fear, as you and those you represent imagine." In other words, an executive action would satisfy the Northern left even as it agitated the Northern right, which would provide a small net political gain at best, and at worst, he added in this extraordinary monologue, test the con-

tinuing loyalty of "fifty thousand bayonets in the Union armies from the Border Slave States" who might "go over to the rebels." "And then unquestionably," he added, "it would weaken the rebels by drawing off their laborers, which is of great importance." Though not yet emboldened to discuss the possibility of recruitment, he cautioned, "I am not so sure we could do much with the blacks. If we were to arm them, I fear that in a few weeks the arms would be in the hands of the rebels."

Lincoln ended his rumination by pointedly cautioning his guests not to misunderstand him "because I have mentioned these objections" to emancipation. "I have not decided against a proclamation of liberty to the slaves," he clarified, "but hold the matter under advisement. And I can assure you that the subject is on my mind, by day and night, more than any other. Whatever shall appear to be God's will," he vowed, "I will do."[79] Lincoln's long preamble was at last over: he had cited military necessity, saving the Union, diplomatic advantage, and divine will; he had assured conservatives that he did not mean to introduce racial equality; and he had exaggerated his commitment to colonization to prepare the country for unthreatening black freedom.[80] By September 15, a New York newspaper issued a front-page story under the headline "Metropolitan Gossip," confirming what many people already knew but admitting "little is said of the long interviews held by Mr. Lincoln with leading northern

statesmen, to whom he submits his well-developed ideas for a proclamation which, when issued, will end the war and its cause. When success shall again have crowned our arms, this important document may be confidently expected; although desperate efforts have been made, are now making and will be made to stifle it with the wet blanket of border state conservatism."[81]

Two days later, Union and Confederate forces met at Antietam Creek. In a final irony, it was that old anti-emancipationist George B. McClellan who did the work Lincoln had left to God, eking out a victory on Wednesday, September 17, and sending Confederate forces retreating back into Virginia. Quickly the president went to work crafting a final proclamation. He made no mention of it at a cabinet meeting on Friday the nineteenth, which is as odd as the fact that no one in the cabinet brought up that day the pledge Lincoln had made the previous July to issue such an order once a victory was won. Lincoln used the weekend after Antietam to refine his document—or, with one eye on George Washington, did he patiently wait for the symbolic twenty-second? Most likely, he simply needed Saturday and Sunday to work on his text without interruption at his Soldiers' Home retreat. On Monday the twenty-first, he called the cabinet back into special session. He began that day's cabinet meeting by reading from a joke book by "Artemus Ward." It is rather revealing that the chap-

ter he selected, albeit to the horror of his grimmer ministers, was "High-Handed Outrage at Utica," which began with the story of a grateful citizenry offering "a cordial recepshun" to the author. Having manipulated the press like a puppeteer for three months, Lincoln must have loved the next sentence, anticipating perhaps that it foretold similar approbation for himself: "The press was loud in her prases."[82]

At the historic cabinet briefing, Blair pressed his objections and warned of political danger. Lincoln himself conceded the continued risk of placing "in greater jeopardy the patriotic element in the Border States," adding "that there was also a class of partisans in the Free States . . . who would have a club put into their hands of which they would avail themselves to beat the administration." But there was no turning back. (Mary Lincoln, who later advised him not to sign the final proclamation, was conveniently away in New York.) As Gideon Welles remembered: "His mind was fixed . . . he had made a vow, a covenant, that if God gave us the victory in the approaching battle, he would consider it an indication of Divine will"—the providential hand of which he had spoken so frankly to the Chicago delegation the previous week. Now, Lincoln concluded, "God had decided this question in favor of the slaves."[83]

So, in a way, had Lincoln's confidants, who had, as the president no doubt expected, discussed, debated, leaked,

published, and in one way or another produced a sense of inevitability for an emancipation policy Lincoln was genuinely eager to unleash. William W. Patton, one of the Chicago ministers who had called on Lincoln a week earlier, publicly acknowledged when serving as president of Howard University twenty-five years later that Lincoln had indeed "intimated" his plan during their meeting, and even confided he had already "made a tentative draft of a proclamation." That bit of news did not make it into the delegation's newspaper account. By then, however, the document had been made public. Still, Patton claimed that "our humble mission was not destitute of some final influence, in resolving doubts and putting an end to delay." As lonely as Lincoln felt that summer, success inevitably has many fathers, and Patton liked to believe that however delayed were the blessings of liberty, "every one may rejoice, who was permitted in any degree to aid in securing them."[84]

That the sieve-like city of Washington absorbed, yet also somehow contained, the stream of both carefully planted and unauthorized news leaks for two long months between July and September 1862 remains something of a miracle. That the public accepted without significant protest the series of broad hints that Lincoln adroitly transmitted during the same volatile period provided still more cause for rejoicing than Reverend

Patton or the administration could have guessed. By confiding, cautioning, clarifying, and caviling, but most of all by waiting, an adroit Lincoln set the stage for the proclamation's inevitability and surprisingly warm reception.[85] Seeming alternatively to be inconsistent, harsh, humble, and ruthless, Lincoln was more accurately patient, wise, prescient, and practical. Appearing to the public at times to be uncertain and inconsistent, he deftly allowed radicals in his confidence to believe he was affirming radical principles, while encouraging conservatives to think he had no other alternative but emancipation if the Union was to keep Europe from choosing sides, swell the ranks of the army, win the war, and restore the federal authority. With his public letters, recorded remarks, and shared secrets, Lincoln did nothing less than succeed in making freedom palatable for whites and possible for blacks.

As we know, Abraham Lincoln loved to tell stories with a message, and in 1864 he told artist Francis B. Carpenter this one: "A man watched his pear-tree day after day, impatient for the ripening of the fruit. Let him attempt to *force* the process, and he may spoil both fruit and tree. But let him patiently *wait,* and the ripe pear at length falls into his lap."[86] Once fallen, of course, the fruit could never be reattached. Even the outmaneuvered Greeley later acknowledged that while Lincoln was

"habitually and constitutionally cautious, he seldom or never felt impelled or required to take a step backward."[87]

Like the man in that tale, Lincoln waited. By means of a sometimes baffling and contradictory web of public relations feints and calculated leaks, the promise of freedom that (at the risk of mixing fruit metaphors) he earlier had likened to an "apple of gold" finally was made to seem to fall into the nation's lap.[88] After a summer-long onslaught of leaks and confidences that variously confused, dismayed, and heartened Americans of all political persuasions—and probably would have impressed even a jaded old political hand turned novelist such as William Safire—official silence and selected revelations had emerged as the chief weapons in Abraham Lincoln's "bow of promise."

In his "peculiar, cautious, forbearing, and hesitating way," an overjoyed Frederick Douglass said at the end of that historic American summer, this "slow, but we hope sure" president had, "while the loyal heart was near breaking with despair, proclaimed and declared ... *Thenceforward and forever free.*" "Read the proclamation," he urged his subscribers, "for it is the most important of any to which the President of the United States has ever signed his name."[89] More to the point, as a columnist for a West Coast African American paper now realized, all of Lincoln's preparatory statements, however offensive or unsatisfying they had appeared earlier, now seemed part of

a logical sequence. It was clear "by close observation," conceded the *Pacific Appeal*, "there could be seen a constant under-current in favor of freedom."[90]

Finally, there is the question of whether Americans of the day should also have seen a relentless pattern of symbolic dates associated not with the sixteenth president but with the first. Recalibrating the evidence, it seems likely that Lincoln had first pronounced his intentions on emancipation on July 22 only because he ran out of time on July 21. He probably withheld response to the August 18 Greeley column until August 22 in order to counter not a four-day-old editorial but a fresh and potentially dangerous newspaper leak that very morning. And it seems likely that he postponed his official announcement of emancipation for five days after the Battle of Antietam until sure that Confederate armies had left Maryland, and until he had taken every bit of an approaching weekend at his country house to hone his document before releasing it.

Of course, George Washington had not planned to be born on the twenty-second, either. And while it is true that Lincoln had long since ceased invoking his name, others stepped forward to make compelling comparisons between the two leaders. From emancipation day forward, Henry Ward Beecher was not the only anti-slavery man in America to express the opinion that Lincoln had been "ordained" to purge the country of "a worse oppression"

than had confronted its founders. "Joined together one and inseparable," he predicted, "we shall hereafter hear on jubilees the shouts of 'Washington and Lincoln!—the Fathers.'"[91] It was surely not lost on Beecher, a long-time critic of the administration's seeming hesitance on freedom, that, vexing silence notwithstanding, Lincoln had finally seized the bow of promise.

2

Emancipator versus Pettifogger

In January 2010—eight score and seven years after America's sixteenth president issued the Emancipation Proclamation—America's forty-fourth president proudly placed a rare, autographed copy of it on display in the very same building where it was first composed and made official: the White House. On Martin Luther King Jr. Day, no less, Barack Obama ordered that the relic be hung directly above the bust of Dr. King that occupies a permanent place of honor in the Oval Office.

To mark the occasion, President Obama held a widely reported meeting with civil rights elders—many of them survivors of the freedom movements of the 1960s—and then ushered them into the West Wing to inspect this newly installed souvenir from the 1860s. Thus began a moment of unavoidable and deeply moving historical symmetry.

What his guests saw there was a rare surviving broadside from a limited edition of just forty-eight, originally printed in 1864 by two leaders of Philadelphia's Civil

War-era Union League. One was its secretary, a banker, lawyer, playwright, and poet named George Henry Boker, known as "the most handsome man in America";[1] the other was locally renowned folklorist Charles Godfrey Leland, a Gettysburg veteran and the self-described "hard working old friend of the Administration"[2] who actually took later credit for coining the word *emancipation* to replace the long-toxic term *abolition* in public discourse.[3] These two enterprising Republicans proposed to publish and sell 21-by-17-inch copies of the proclamation to benefit the U.S. Sanitary Commission, a precursor of the Red Cross that ministered to wounded soldiers.

Boker and Leland spared no expense in making faithful editions. Under the supervision of the State Department, they typeset drafts and proofs, and only when fully satisfied did they send the four dozen final copies off to Washington to be signed by the president and Secretary of State William H. Seward. Lincoln was unusually preoccupied at the time: the all-important Republican National Convention was only a week away, and he was busy wheeling and dealing to secure nomination for a second term, weighing the pros and cons of finding a new running mate, and ensuring that the party platform include a plank calling for a constitutional amendment to outlaw slavery everywhere. But George H. Boker was undeterred. As he described his request to the president's private secretary John G. Nicolay: "It is a

small thing to ask; but we can make it of great pecuniary value to the Fair."[4]

Nicolay knew a reputation-making opportunity when he saw it: when the broadsides were returned to Philadelphia, they bore not only Lincoln's and Seward's signatures but Nicolay's as well. How did Nicolay get his beleaguered boss to sign four dozen broadsides? We cannot know for sure, but Lincoln likely proved willing to participate in the project not only because of its promised benefit to wounded soldiers but also, at least in part, out of gratitude to the Union League. It had made him an honorary member of the Philadelphia chapter just eight months earlier, an honor the president had accepted by pledging to the club's "patriotic" members— and potential supporters in his upcoming bid for re-election—"to do my duty in the trying times through which we are passing."[5] Now he was doing that duty, repaying a political debt in a move he no doubt expected would reap further dividends for his campaign in the coming months. But surely he was doing something more: aiding and abetting the transfiguration of a prosaic piece of writing into a canonical national treasure. And the chief beneficiary of such a metamorphosis would be Lincoln himself.

As promised, Boker and Leland went on to offer the signed broadsides at ten dollars apiece at the Philadelphia Great Central Sanitary Fair later that June—just

days after Lincoln won his party's nod for a second term and the convention had proposed an amendment to the Constitution abolishing slavery. The only piece that did not fall into place was the anticipated public enthusiasm for the proclamation.

For while the Philadelphia fair attracted more than a hundred thousand visitors, several of the reproductions went unsold. This is hard to explain. Conceivably it was a sign that not everyone, not even in the city of brotherly love, yet endorsed the liberty order sincerely enough to embrace it as an icon. If such was the case, skepticism reigned even though Lincoln made a rare trip from Washington to visit the fair personally, making three different speeches to enthusiastic audiences both at his hotel and at Union League headquarters, specifically telling one audience that he hoped "my presence might do some good towards swelling the contributions of the great Fair in aid of the Sanitary Commission, who intend it for the soldiers in the field."[6] Apparently it did not.

The items were certainly not priced beyond the art, artifacts, machinery, and crafts on display. It cost two dollars merely to attend the fair, and multitudes did so, reportedly spending a total of one million dollars during its twenty-two-day run.[7] Had the recent national convention politicized Lincoln and his order? Perhaps, but political campaigns in nineteenth-century America

invariably widened demand for collectibles and display pieces; they did not suppress it.[8] Of course, this president was not exactly popular at the time: after three years of bloody and costly war, the Northern public was growing deeply impatient with its leader, and Lincoln himself expected for months to come that he would be defeated in the fall elections. The project involved not thousands of souvenirs for purchase but only forty-eight. So we must ask ourselves whether their sluggish sales might then be attributable to the words of the document. In the abstract they had changed the war, changed the armed services, and changed the nation. But any prospective customer who carefully studied a copy at the Philadelphia fair might well have been reminded that, phrase for phrase, the proclamation was rather less than the sum of its parts.

All we know for sure is that only five months later, its co-publisher suggested that the remainder "be disposed of" in some other way, ideally "for the benefit of those who are now fighting for their country." That November—the month of the presidential election—he sent five broadsides to sell at another Sanitary Commission–backed charity event, the National Sailors' Fair in Boston. There the remaining "autograph emancipation proclamations" presumably found an appreciative audience at last; at least we know of no more leftover copies or additional venues.[9] Even so, we cannot help feeling they

had been disposed of in what amounted to a bargain sale.

Yet a century and a half later, one of the now highly prized surviving copies from this initially unsubscribed edition achieved a place of honor in the office of the president of the United States. Among the visitors to the Oval Office on Martin Luther King Jr. Day was a 101-year-old lady named Mabel Harvey, who confided to the president in words that neatly summed up the nation's transfiguration, not to mention the document's: "This must be the Lord's doing, because we've come a mighty long way."[10]

So has the Emancipation Proclamation—both admired and criticized over the years, lamented for its limitations and legalese, yet reverenced by a long line of American presidents, starting with Lincoln himself. Yet the question lingers, just as it remained unanswered when these reprints failed to sell out in Philadelphia: had President Obama, Mrs. Harvey, or anyone else actually read the words that constituted, in many contemporary assessments, America's second Declaration of Independence?[11] And if they had, would they have reacted differently?

Lincoln himself boasted that he believed the document represented a "grand consummation" that inspired a "great revolution in public sentiment."[12] But the truth is, its text, word for word, has struck many observers not

only as less than "grand" and "great" but as inconsistent with, perhaps even insensitive to, the document's purported intent. If it was meant to stir public sentiment, it was remarkably short on sentiment itself.

The issue continues to challenge and divide historians. Henry Louis Gates Jr., for example, has suggested that the order was crafted only with "the precision of a constitutional legal brief."[13] But was this a shortcoming or a virtue? For answers, we might look again to its original reputation, its power as an icon, and its proliferation in reprints. Through this new window, we might more accurately view and measure the evolving reputation of the document, as well as the motives and mechanics of its author in forgoing ringing poetry for rigorous and uninspiring prose.

One thing is certain: Lincoln never doubted himself or his document. As he told witnesses on New Year's Day 1863—pausing before affixing his name to it because his right arm was "almost paralyzed," as he put it, from three hours of unrelenting holiday handshaking: "If my name ever goes into history it will be for this act, and my whole soul is in it."[14] Yet clearly he did not offer the endeavor his whole supply of literary skill. While the first Declaration of Independence began with the unforgettable phrase "When in the course of human events," the so-called second Declaration started with "Whereas, on the twenty-second day of September, in the year of

our Lord one thousand eight hundred and sixty-two, a proclamation was issued by the President of the United States, containing among other things the following, to wit. . . ." Fair enough: many of Lincoln's proclamations were built around similar templates. But the rest of this one did not cite "life, liberty, and the pursuit of happiness" but instead offered paralyzing phrases such as "attention is hereby called" and "I do hereby enjoin." The document almost groans under the burden of leaden, legalistic terminology: two "therefores," one "thereto," two uses of "to wit," and two "aforesaids."

On the other hand, the word "free" appears but three times, first merely in quoting the preliminary proclamation that had been issued a hundred days earlier with fair warning that the final order would be issued unless the rebellious states put down their arms and returned to the Union, and later to admonish liberated people to "abstain from all violence, unless in necessary self-defence."[15] The majority of the text was given over not to discussing the promise of freedom but to listing exemptions and exceptions. Its one stylistically redeeming sentence—"upon this act, sincerely believed to be an act of justice . . . I invoke the considerate judgment of mankind, and the gracious favor of Almighty God"—was suggested not by Lincoln but by his secretary of the treasury, Salmon P. Chase. While saluting emancipation day as "an epoch in our national history," Frederick Doug-

lass spoke for many anti-slavery contemporaries by practically apologizing for the proclamation's banal language, explaining that Lincoln "could hardly hope to satisfy all, even of Freedom's friends."[16]

It is no wonder that it has long been under attack ever since in scholarly circles, particularly in the twentieth century. Historian Richard Hofstadter offered the most devastating criticism of all, famously deriding the Emancipation Proclamation as boasting "all the moral grandeur of a bill of lading."[17] Hofstadter was by no means the first observer to make such a derisive assessment of Lincoln's efforts to write what might be called his freedom documents. The abolitionist Thaddeus Stevens, for one, considered Lincoln's spring 1862 call for gradual compensated emancipation in the border states the "most diluted milk-and-water-gruel proposition that was ever given to the American nation."[18]

That autumn, a contemporary European Lincoln admirer named Karl Marx similarly complained that Lincoln's preliminary Emancipation Proclamation called to mind "the trite summonses that one lawyer sends to an opposing lawyer, the legal chicaneries and pettifogging stipulations of an *actiones juris*"—a court case. Marx found it perfectly astonishing that what he called "the most significant document in American history since the founding of the Union and one which tears up the old American Constitution, bears the same character," al-

though its literary shortcomings did not alter its "historic content." Marx came amazingly close to the truth when he offered this assessment of Lincoln as a writer: "He always presents the most important act in the most insignificant form possible. Others, when dealing with square feet of land, proclaim it a 'struggle for ideas.' Lincoln, even when he is dealing with ideas, proclaims their 'square feet.' Hesitant, resistant, unwilling, he sings the bravura aria of his role as though he begged pardon for the circumstances that force him 'to be a lion.'"[19]

But exactly why, observers have wondered before and since, did the lion fail to roar at a moment of such awesome historic importance? Hofstadter is not the final document's only widely quoted modern critic. The mid-twentieth-century historian Benjamin Quarles, who considered Lincoln a genuine liberator, nonetheless observed a "lack of any exalted sentiment" in the proclamation, and criticized both its author *and* its audience by complaining that its "dry, matter-of-fact style" "did not disturb" African Americans of the time. In Quarles's judgment, blacks overlooked the fact that it was written almost as if "Lincoln's heart were not in it," simply because it "contained the words 'henceforward shall be free.'" As Quarles put it: "In a document proclaiming liberty, the unfree never bother to read the fine print."[20]

The great midcentury Lincoln scholar James G. Randall similarly acknowledged: "Limitations in the famous proclamation itself, with its definite lack of a kingdom-

come quality, produce a sense of amazement.... One could almost say he did not like his most famous act." And yet Randall conceded that the proclamation "was admired at a distance," eliciting a "vague aura of glory," explaining: "Legal provisions as they would appear in a court were not the main concern of jubilating hearts."[21]

More recently, Lerone Bennett Jr. caused a sensation by condemning the proclamation outright as one of the "generic expressions of the character and orientation of Abraham Lincoln, who seems to have had a vocation for emancipating slaves without emancipating them." Though historian George Fredrickson, in a Huggins Lecture delivered in 2006, described Bennett's criticism as "the culmination of a gradual process of African American disenchantment with Lincoln," the *Ebony* editor had in fact specifically aimed his critique at a narrower target: the document's literary style—or absence of it. To Bennett, "there is no hallelujah in it. There is no new-birth-of-freedom swagger, no perish-from-the-earth pizzazz."[22]

In a way, albeit more colloquially, Bennett was expanding on what Frederick Douglass said at the emancipation moment, after campaigning mightily for the document to be issued. When it finally was, Douglass almost ruefully observed: "It was not a proclamation of 'liberty throughout the land, unto all the inhabitants thereof,' such as we had hoped it would be, but was one marked by discriminations and reservations." Nonetheless, as he conceded in a speech at Cooper Union a year

after its issuance, "it was a vast and glorious step in the right direction."[23]

Douglass was on to something crucial with these observations. For throughout the North, lovers of freedom, black and white, marked New Year's Day 1863 with similar expressions of religious fervor: gathering in churches, waiting and praying for the midnight hour to usher in liberty to all the inhabitants of divided America (though the signing was delayed by Lincoln's New Year plans and a transcription error), and applying biblical metaphor to welcome the document's publication. If the document whose words finally came across the telegraph wires that afternoon bore none of the grandeur or Book of Exodus fervor for which Douglass and others had yearned, it nonetheless soon achieved the iconic status of a holy writ—even if it later distressed people rereading it. It is little wonder that Douglass himself called Lincoln the "black man's President" in 1865, yet at the dedication of an emancipation sculpture in Washington just eleven years later reversed himself completely and described him as "preeminently the white man's president."[24] The proclamation—both at first blush and in retrospect—had a way of inspiring conflicted reactions.

Right or wrong, the proclamation has earned twin, concurrent, and disparate reputations as both a free-

dom icon and a rhetorical failure, as the kind of relic Barack Obama could proudly display generations after fair-goers greeted it tepidly and years after historians savaged it. And perhaps nothing better illustrates these oddly conflicting historical currents than the document's own strange history as both a talisman and a piece of literature and archival history, a parallel legacy directly influenced by two of the nation's unique Civil War social movements: the mostly political Union League movement, dedicated to Republican politics and black enlistment, and the U.S. Sanitary Commission movement, dedicated to the care and feeding of Union soldiers and sailors, especially the wounded. Both of these organizations played major roles in burnishing the reputation of the proclamation among the public. They ignored its shortcomings as political literature and secular gospel, sidestepped its inflammatory ability to generate controversy in racist white America, and instead embraced its potential as a relic of almost messianic power. Lincoln's personal participation in this metamorphosis is particularly illuminating. At first an anxious emancipator, he chose to dispose of the freedom document itself in a way that constitutes as revealing a story as that of how slowly and narrowly he composed it.

It is important to keep in mind that Lincoln authored three Emancipation Proclamations, not one or even

two: the rough draft he read to his cabinet on July 22, 1862, and then tabled; the official Preliminary Emancipation Proclamation, totally rewritten before it was released to the public on September 22 of that year; and then the final, official executive order issued one hundred days later on January 1, 1863.

In late spring or early summer 1862, in the face of almost universal rejection of his plea to border states for gradual compensated emancipation, Lincoln began drafting an executive order that would both widen and command military enforcement of the Confiscation Act passed by Congress on July 16. We are not certain precisely where he crafted his words—perhaps on a steamship bearing him home from a visit to Union troops in Virginia, or in the War Department telegraph office near the White House, or perhaps in part at the Soldiers' Home, his summer cottage north of Washington. This retreat he customarily reached by riding horseback, often past contraband camps that seemed to be swelling in population with each commute, a condition that, together with congressional initiatives and press impatience, added to the pressure on the president to move expeditiously. Wherever he worked out his thoughts, there is evidence that Lincoln found their composition a daunting, even agonizing process from the very beginning. One witness remembered him scribbling no more than a few words at a time. "He would look out of the

window for a while, and then put his pen to paper, but did not write much at once. He would study between times and when he had made up his mind he would put down a line or two, and then sit quiet for a few minutes. After a time he would resume his writing." By the end of the day on which he was observed, Lincoln had written less than a page: it hardly seemed the outpouring of a man inspired.[25]

As for the first publicly released document, whatever its literary shortcomings, there was no denying its impact. Lincoln's clerk William O. Stoddard never forgot the afternoon one of his office colleagues rushed into his White House office and, "with a sort of flush on his face," placed a paper before him and told him the president wanted him to make two copies "right away." This of course meant transcribing by hand, not photocopying or scanning. At first, Stoddard remembered, he "went at it, mechanically," until what he called "a queer kind of tremor" began "shaking my nerves" as he began realizing just what he was writing. Now he began imagining he could "hear the sound of clanking iron, as of breaking and falling chains, and after that the shouts of a great multitude and the laughter and the songs of the newly free and the anger of fierce opposition, wrath, fury, dismay. For I was writing the first copies from Abraham Lincoln's own draft of the first Emancipation Proclamation."[26]

Stoddard's response—initial indifference to the individual words, followed by deep appreciation of their import—was mirrored throughout the country when the preliminary proclamation was issued. Abolitionist William Lloyd Garrison called it "a matter of great rejoicing, as far as it goes." Though he hastened to point out that the nation "still needed . . . a proclamation, distinctly announcing the total abolition of slavery," Lincoln's order was enough to inspire him to quote Scripture to declare that he, and "a great multitude of others, 'do rejoice, and will rejoice.'"[27] Massachusetts governor John A. Andrew concurred, calling it "a poor document, but a mighty act."[28] Even a persistent critic such as journalist George William Curtis was moved to concede: "The President may be a fool, but look what he has done. He may have no policy. But he has given us one."[29]

Not everyone agreed. Lincoln's uninspiring document moved foreign-born Washington gadfly Adam Gurowski to complain, "The proclamation is written in the meanest and most dry routine style; not a word to evoke a generous thrill, not a word reflecting the warm, and lofty comprehension and feelings of the immense majority of the people on this question of emancipation. Nothing for humanity, nothing to humanity . . . it is clear the writer was not in it either with his heart or with his soul; it is clear that it was done under moral duress, under the throttling pressure of events." Then, quoting Union gen-

eral James Wadsworth, he concluded: "Never a nobler subject was more belittled by the form in which it was uttered."[30]

It was no surprise that longtime anti-slavery military officers such as the Harvard-educated Wadsworth were disappointed. But Lincoln faced much greater danger, as he well knew, from the conservative wing of the military—filled with Democrats—where opposition could foment insubordination and worse. Surely that understandable concern was one of Lincoln's chief motivations for keeping celebratory hallelujahs out of the document. Indeed, General Fitz John Porter immediately told the editor of the anti-Lincoln *New York World* that the "absurd proclamation" was the work of "a political coward," revealing that it had been "ridiculed in the army—causing disgust, discontent, and expressions of disloyalty." Most alarming of all, the chief commander of the Army of the Potomac, George B. McClellan, whose victory at Antietam had emboldened the president to issue the document, told his wife that its publication made it "almost impossible for me to retain my commission & self respect at the same time. I cannot make up my mind to fight for such an accursed doctrine as that of a servile insurrection—it is too infamous."[31]

Even from a friendly civilian crowd that serenaded him on the White House lawn on September 24, Lincoln asked and anticipated no accolades. Anxiously

describing himself as "environed with difficulties," he proclaimed almost defensively: "What I did, I did after very full deliberation, and under a very heavy and solemn sense of responsibility. . . . It is now for the country and the world to pass judgment on it."[32] There was no doubt but that he remained uncertain of what that judgment would be.

Dangers existed on many fronts even though Lincoln employed a minimalist and legalistic approach not only to certify his authority to act but also to damp down what he worried up to the last minute would be a potentially crippling public outcry—perhaps enough to drive a border state or two out of the Union, doom the Republican Party to a disastrous midterm election result in November, and embolden the neutral but unpredictable capitals of Europe to recognize the Confederacy as a separate nation. Lincoln proved prescient on all counts. Speaking for Great Britain, the *Times* of London quickly condemned the order as "pompous," and a "nefarious resolution" of "impotent malignity" certain to "light up a servile war in the distant homesteads of the South" while rewarding slaveholding border states for their "loyal tyranny." Perhaps as baffled by his style as many Americans were, the *Times* offered a dismal, almost mocking, appraisal: "This is more like a Chinaman beating his two swords together to frighten the enemy than

like an earnest man pressing on his cause in steadfast-ness and truth."[33]

Northern editorials proved more flattering, of course, but to his own vice president, Lincoln remained no less fearful, confiding: "While commendation in newspapers and by distinguished individuals is all that a vain man could wish, the stocks have declined, and troops come forward more slowly than ever. This, looked soberly in the face, is not very satisfactory.... The North responds to the proclamation sufficiently in breath; but breath alone kills no rebels."[34] When Lincoln's party went on to lose thirty-one seats in Congress, plus governorships and state legislatures both east and west, the president's darkest fears came true. As one border state newspaper headlined the electoral rebuke: "Fanaticism, Abolition-ism, and Niggerism Repudiated."[35] A month later, mat-ters went from bad to worse when the Union Army lost disastrously at the Battle of Fredericksburg. These set-backs compelled Lincoln to craft his next and final proclamation with almost microscopic precision.

The preliminary proclamation made no pretense to oratory or literature, to warmth or enthusiasm, or even to immediate impact, since it gave Confederate states one hundred days' notice to return to the Union and thereby avoid confiscation of their human property entirely, and did so in language that was icily formal. Lincoln cited

his authority to act as president and commander in chief, and included sections of the recently passed congressional Confiscation Act—more than "included," to be precise, as he actually cut out and pasted excerpts so that he would not have to rewrite them, leaving for all the world to see for all time a fat fingerprint testifying to his meticulous craftsmanship. He also cited his overall goal to be reunion rather than liberation, and reiterated his commitment to gradual emancipation in the loyal slave states and to voluntary colonization of "persons of African descent."[36] The result seemed rhetorically bland enough to hold critics in check, legally sound enough to survive threats of court challenges, and militarily strong enough in promising the underachieving Union Army a new infusion of manpower.

The anti-administration, anti-slavery *Chicago Times* may have been disappointed: its editors yearned for "a prophet's word."[37] But its pro-administration rival, the *Chicago Tribune*, exulted, "So splendid a vision has hardly shone upon the world since the day of the Messiah."[38] Frederick Douglass, too, saw the proclamation as the act of a deliverer. "We shout for joy that we live to record this righteous decree," he wrote in the October issue of *Douglass' Monthly*, quoting the prosaic text with biblical fervor:

"Free forever" oh! long enslaved millions, whose cries have so vexed the air and sky, suffer on a few more days in

sorrow, the hour of your deliverance draws nigh! Oh! Ye millions of free and loyal men who have earnestly sought to free your bleeding country from the dreadful ravages of revolution and anarchy, lift up now your voices with joy and thanksgiving for with freedom to the slave will come peace and safety to your country.[39]

As if to supply a congregation's loud amen, correspondents from throughout the North offered approbation similarly laced with religious fervor. Calling his "Proclamation of Freedom" an "annunciation that America is dedicated to Free Men and Free Institutions," for example, three Erie, Pennsylvania, men wrote Lincoln to say: "God bless you . . . our cause receives an inspiration unknown before; and having now won God to our side . . . the Nation *cannot* die."[40] The preliminary document's prose surely did not matter to Ralph Waldo Emerson, who hinted that it was "a poetic act . . . inspired by genius." To Emerson, the order seemed all the more powerful precisely because it was issued "without inflation or surplusage." The explanation lay with a higher power. As great as Lincoln's personal popularity was, Emerson struggled to explain, "we are beginning to think that we have underestimated the capacity and virtue which the Divine Providence has made an instrument of benefit so vast."[41] In more practical and surely more troubling terms, a *New York Herald* correspondent traveling with

Union forces in Virginia worried that Lincoln's proclamation would "go far towards producing an expression on the part of the Army that will startle the Country and give us a Military Dictator."[42]

Ultimately, response in progressive quarters to the even more legalistic final proclamation echoed the cacophony of hosannas. As early as Christmas Day 1862, a week before it was scheduled to take effect, Americans were already clamoring for pieces of the anticipated cross. George Livermore of Massachusetts was one notable case. A merchant turned antiquarian who earlier that year had delivered a treatise titled *Opinions of the Founders of the Republic, on Negroes as Slaves, as Citizens, and as Soldiers*—showing that the fathers of their country had embraced the prospect of African American recruitment—Livermore was not only a noted amateur scholar but also an avaricious collector. Now he had the presence of mind to beg Senator Charles Sumner to obtain for him what he considered would be regarded as a "precious instrument": the pen Lincoln used to sign the final order. "God bless Abraham Lincoln will rise from millions of hearts & tongues," Livermore gushed. "I do want to get and to keep the *pen* with which he signs this Declaration of Independence."[43] Livermore's comment demonstrated something more than an incurable collector's lust to acquire; it shows that even before its publication, the document was being likened to American scripture.

Lincoln obliged Sumner by ultimately awarding the cedar-handled, steel-nibbed pen to Livermore, and the collector responded ecstatically.[44] Ignoring the proclamation's own notable lack of grandiloquence, he proclaimed: "No trophy from a battlefield, no sword red with blood, no service of plate with an inscription, as complimentary as the greatest rhetorician could compose, would have been to me half as acceptable as this instrument which will forever be associated with the greatest event of our country and our age & with the honored names and services of the President of the United States."[45]

Livermore was not the only American who clamored for such "instruments" in advance. As Congressman Schuyler Colfax advised Lincoln on New Year's Eve: "New York Editors are anxious, if possible, that your proclamation if ready, may be telegraphed to the Associated Press this afternoon or evening, so that they can have it in their New Year's morning newspapers with Ed[itoria]l. articles on it." Colfax fretted that if the document failed to attract coverage on January 1, publication would be delayed until January 3, "robbing it of its New Year's character."[46]

A canny observer, and skillful manipulator, of public opinion, Lincoln probably would have preferred to oblige. The truth was, as late as December 30, he was still awaiting comments from members of his cabinet on his

latest draft. He had good reason to doubt their enthusiastic support: back in July, as we know, they had urged him to refrain from issuing a preliminary proclamation at all. In September he had told them bluntly that he had made a pact with God to issue one then and there, with or without their consent. Now, in the final hours of this momentous year, Lincoln continued to seek consensus. As he massaged his text to make it legally fireproof, he deliberated with his ministers over such proposed clauses as a patronizing admonition to freed blacks to refrain from violence, along with, by contrast, a truly revolutionary invitation to African Americans to join the Union armed forces. Ignoring the transitory appeal of holiday glory, Lincoln rejected haste and turned down the editors.[47] The press could wait because history would be patient. The silence from the White House, however, ignited rumors that Lincoln would in fact blink and let the January 1 deadline pass without signing the order at all. Correspondents flooded the mansion with importuning letters begging him to make good on his promise. Observers such as George Templeton Strong of New York worried about whether "Lincoln's backbone" would "carry him through the work he is pledged them to do. . . . If he come out fair and square," Strong confided to his diary, "he will do the 'biggest thing' an Illinois jury-lawyer has ever had a chance of doing, and take high place among the men

who have controlled the destinies of nations. If he post-pone or dilute his action, his name will be a byword and a hissing till the annals of the nineteenth century are forgotten."[48]

They need not have worried. As Lincoln had only recently assured a delegation of Union men from his native Kentucky, "he would rather die than take back a word of the Proclamation of Freedom."[49] A day after Christmas, Charles Sumner had confidently told the souvenir-minded George Livermore: "The President says he would not stop the Proclamation if he could, and could not if he would."[50]

As those close to the situation soon learned, however, the endless hours of preparation did not mean that history would be given ornate or memorable phrases to consecrate the momentous occasion. Indiana editor John D. Defrees begged Lincoln for "such a document as to justify the act in all coming time."[51] But H. L. Mencken later shrewdly observed that when it most counted, Lincoln "purged his style of ornament"—of the "empty fireworks" and "childish rhodomontades [sic] of the era."[52] Yet there was more to Lincoln's insistence on numbing legalese. After the political and military disas-ters of November and December, Lincoln wanted not a proclamation that would please literary critics but one that would survive challenges in the courts; not a decla-ration that would enthrall the enslaved but one that

would seal the cooperation of the free: white men who had no tolerance for black men.

In the face of intractable race prejudice and mounting dissatisfaction with the administration, and as Congress debated whether the president should issue his final order, Lincoln chose, as historian Phillip Shaw Paludan put it, to "mute his empathy," even if it risked giving future generations the sense that he lacked empathy altogether.[53] Or as Lincoln scholar Mark Neely has suggested, Lincoln was simply "too worried about his potential domestic critics to unleash the full powers of his language." And this is true. Lincoln needed a proclamation that would disarm domestic foes on the left and right alike, and somehow rally the center. He needed a proclamation that would neutralize potential foreign foes—not only the British, who were bent on building ships for the Confederacy, but also the French, who had already planted a puppet government in Mexico. Lincoln needed to limit his approach—and grant distasteful exemptions—so border slave states such as Kentucky did not react by seceding and joining the Confederacy. He needed to anticipate and eliminate legal and constitutional challenges by acting narrowly as the commander in chief with a tightly argued, precisely worded military order that also would survive the war, even if the appeals went all the way to the Supreme Court.[54] And he needed as well to recruit blacks for a

weary armed force that preferred fighting for the Union, not freeing slaves, much less fighting alongside them.[55]

Nor, in another important sense, did the occasion truly call for rhetorical flamboyance. Lincoln saw the final proclamation as a formal recounting, and redemption, of the promise behind the warning he had plainly issued back in September: that slave states must either return to the Union or forfeit their slaves forever. He was now prepared calmly to summon his war power and make good on the government's pledge—to use the army to enforce it, and to recruit the untapped African American manpower that freedom unleashed and use it against the rebels.[56] As he later justified the deployment of African Americans and, implicitly, his choice of words in authorizing their recruitment: "It is not a question of sentiment or taste, but one of physical force, which may be measured, and estimated as horse-power, and steam-power, are measured and estimated. And by measurement, it is more than we can lose, and live." This was not the time, the great writer said with almost palpable regret for restraining himself, for "magic, or miracles."[57]

That this was the proper course to pursue was ratified, or at least endorsed, just a few days before the New Year, when Horace Greeley's *New York Tribune*, the same newspaper that had demanded emancipation in August, now damped down public expectations for a ringing freedom document in January. Explaining in advance

the anticipated lack of inspirational heft, the *Tribune* broke the story that the decree would be less dramatic than many Americans expected:

> The President has been strongly pressed to place the Proclamation of Freedom *upon high moral grounds, and to introduce into the instrument unequivocal language testifying to the negroes' right of freedom upon the precise principles expounded by* the Emancipationists of both Old and New England. This claim is resisted, for the reasons that policy requires that the Proclamation be issued as a war measure, and not as a measure of morality; and that Law and Justice require that the slaves should be enabled to plead the Proclamation hereafter if necessary to establish judicially their title to freedom. They can do this, the President says, on a proclamation *proceeding as a war measure from the Commander-in-Chief of the Army, but not on one issuing from the bosom of philanthropy.*[58]

It is no surprise that the *New York Times* promptly reprinted its rival's scoop. Only a few weeks earlier, its pro-Republican editor, Henry J. Raymond, had strongly advised the president to do just as the *Tribune* now hinted he would. In an important letter that has escaped the attention of historians, the conservative Raymond warned that "any attempt to make this war *subservient* to the sweeping abolition of Slavery, will revolt the Border

States, divide the North and West, invigorate and make triumphant the opposition party, and thus defeat *itself* as well as destroy the Union." On the other hand, he offered, "an effort to use emancipation, within the limitation of law, against rebels as a *military weapon* purely & exclusively, will be sustained by the whole country, Border States and all." Specificity and proscription, Raymond urged, would avoid "the public odium and dissension inevitable in a more sweeping and less guarded movement." And caution, he knew, would "free just as many slaves and thus attain the same practical results." As Raymond almost prophetically concluded: "The only drawback I can think of is, that such a mode of reaching a result will not suit those who deem the *mode* of more importance than the result itself." Thanking the influential New York editor, Lincoln promised to "consider and remember your suggestions." And, similarly believing the result more important than the mode, he did.[59]

This approach even Garrison understood. "His freedom to follow his convictions of duty as an individual is one thing," he wrote of Lincoln, but "as the President of the United States, it is limited by the functions of his office; for the people do not elect a President to play the part of a reformer or philanthropist, nor to enforce upon the nation his own peculiar ethical or humanitary ideas."[60] Lincoln's navy secretary, Gideon Welles, agreed. Acknowledging the reigning feeling that Lincoln's

"philanthropic and humanitarian feelings" had prompted emancipation, the secretary of the navy suggested otherwise without denying Lincoln's basic "benevolence." As Welles put it: "He had the kind and generous nature imputed to him, but . . . was governed, not by sympathy for the slave, but by a sense of duty, and the obligation which as Chief Magistrate he owed to his country."[61]

As it turned out, limiting its philanthropic breadth did little to quell the outrage emancipation inspired from conservatives. Sensing that Lincoln's "change of attitude is itself a revolution," the *New York Times* applauded the "great precision in his language" while regretting that the president had not issued it as a pure military order, rather than a "Proclamation addressed to the world at large."[62] Although Lincoln had couched his thunderbolt in the muffled language of a legal writ, anti-administration journals saw past this and responded venomously. The *Chicago Times* called it "a wicked, atrocious and revolting deed for the liberation of three million negro barbarians and their enfranchisement as citizens," and the New York *Irish-American* branded its supporters "Nigger propagandists" and raged: "We have no words to express the loathing and contempt we feel for the besotted fanatics."[63] The British chargé d'affaires in Washington, William Stuart, termed it "trash" from an "utterly and powerless" government that "could scarcely be treated seriously."[64]

This time, however, while its text was hardly more inspiring than that of the preliminary document, the antislavery movement simply ignored the prose altogether, instead celebrating the consequences and lauding both God and the man many believed had been ordained to act on heaven's instructions. "It is a great historic event," Garrison exulted in the *Liberator*, delaying the weekly's appearance by one day for the first time in its history in order to await and praise the publication of the proclamation. To the old abolitionist, it seemed "sublime in its magnitude, momentous and beneficent in its far-reaching consequences, and eminent just alike to the oppressor and the oppressed."[65] Harriet Beecher Stowe later likened Lincoln to "Moses leading his Israel through the wilderness," mixing her metaphors—or at least her Testaments—to argue: "His rejection of what is called fine writing was as deliberate as St. Paul's."[66]

Within a week, many of the simple Americans to whom Stowe believed Lincoln aimed all his efforts, proclamations, letters, and speeches responded accordingly. In one case, a clerk on a federal warship wrote to the president offering to distribute copies "in the Cotton states," in return for wages, expenses, and promotion as an officer of "secret agent." In a perhaps more rewarding message, a missionary in distant Persia wrote to tell Lincoln that his words had been translated and published in Syriac, reminding him "that in distant Persia,

hundreds and perhaps thousands are learning to rever-
ence your name among the oppressed Nestorians of
Persia and of Koordistan, and that American citizens
are there daily offering prayers to heaven for its bless-
ings upon you."[67]

The public never clamored for the July draft
proclamation, of course, because only a few people knew
of its existence. But strong interest greeted both the Sep-
tember and the January documents. In both cases, that
passion was focused not on reproductions but on
scarcer bait: unique, handwritten documents that sold
not to the multitudes but to individual, wealthy, and in-
fluential Republicans. Replicas did follow—eventually—
and, as it turned out, the Boker printing's mixed recep-
tion in Philadelphia ultimately turned out to be an
anomaly, the exception and not the rule. But Lincoln's
dry words did not adapt quickly or easily into the kind
of attractive display pieces that nineteenth-century
Americans favored for institutional or home display.

Not surprisingly, it was the third and final emancipa-
tion document that first achieved iconic status. Much of
the credit must go to an indefatigable charity organizer,
nurse, editor, and poet named Mary Ashton Rice Liver-
more (her minister-husband Daniel no known relation
to pen collector George), who served as coordinator of

the northwestern branch of the U.S. Sanitary Commission.[68] In November 1862, she had visited Lincoln in the hope he would offer encouraging words on the conduct of the war, only to hear the gloomy president declare: "I have no word of encouragement to give!"[69]

Eleven months later, Lincoln had just such a word to give, and Mrs. Livermore wanted him to give it—to her. In October 1863 she wrote Lincoln to alert him to the forthcoming Great Northwestern Sanitary Fair, designed to raise funds for "sick and wounded soldiers." "Artists . . . are painting pictures for it," she boasted, "manufacturers are making elegant specimens of their handiwork for the occasion, tradesmen are donating the choicest of their wares, while women are surpassing their ordinary ingenuity and taste in devising beautiful articles for sale, or decorations for the walls of the four spacious halls we are to occupy." Mrs. Livermore had the audacity of hope that seems to dwell within Chicagoans: she requested one additional, spectacular donation, "not so much for the value of the gift, as for the eclat which this circumstance would give to the Fair. It has been suggested to us from various quarters," she ventured, "that the most acceptable donation you could possibly make, would be *the original manuscript of the Proclamation of emancipation.* . . . There would be great competition among buyers to obtain possession of it, and to say nothing of the interest that would attach to such a

gift, it would prove pecuniarily of great value." And Mrs. Livermore pledged: "We should take pains to have such an arrangement made as would place the document permanently in either the State or the Chicago Historical Society."[70]

For a time, Lincoln ignored the request—even after he received an eighty-seven-page petition, signed by some twenty-five hundred Chicago women, urging him to attend the fair with Mrs. Lincoln.[71] His reluctance was understandable. After all, however noble their cause, the fair organizers were asking for nothing less than his original manuscript—the handwritten text from which government scribes had made the official copy on vellum for his New Year's Day signature. Knowing its value, clerk William Stoddard had tried, he later confided, to hide it in his desk drawer and "'smouch' it" for himself.[72] Lincoln no doubt had other ideas for it. But Mrs. Livermore was undaunted; when she heard nothing from the White House, she dispatched two heavyweight Illinois politicians to rattle the plate for the Chicago extravaganza. First Congressman Owen Lovejoy poured on the biblical flattery by telling the president: "If you do not deposit it in the Archives of the Nation, it seems to me that Illinois would be a very suitable resting place for a document that ought to be laid away in some holy place like the ancient Jewish symbols."[73] His message was clear: Lincoln had become another Moses, and his words now belonged to the people. A week later, Lovejoy's

House colleague Isaac N. Arnold, well known for bring-
ing home the bacon to the Cook County district he rep-
resented in Congress, wired to "remind" Lincoln of the
outstanding request, and to "beg you will send the proc-
lamation of Freedom if possible."[74]

Twelve days later, Lincoln finally bowed to the pres-
sure and sent his manuscript to Mary Livermore. "I had
some desire to retain the paper," he frankly admitted,
"but if it shall contribute to the relief or comfort of the
soldiers that will be better."[75] Despite a recent and
"wonderful outpouring" of other donations, Mrs. Liver-
more was understandably ecstatic and told the president
he had done nothing less than "bestow the most noble
and valuable gift" of all. "Your proclamation," she
enthused,

is the star of hope, the rainbow of promise, that has risen
above the din, and carnage of this unholy rebellion, and
will fill the brightest page in the history of our struggle
for national existence; while it has become the anchor of
hope, the rainbow of promise, to the oppressed of every
land, at home and abroad.

Offering no evidence of the skepticism that would rear
up soon thereafter in Philadelphia, she promised that the
"treasure will be carefully guarded & skillfully managed,
so as to produce a revenue, that shall make your heart
glad, and soothe the woes of hundreds in hospitals."[76]

She lived up to her word. The fair attracted 100,000 spectators, and amidst the exhibits they saw of "mowing machines, reapers, threshing machines, planters, [and] pumps," the display in Bryan Hall of the "gift of the President to the fair," said the official bulletin of the Sanitary Commission, meant that "thousands of dollars will probably be realized from its sale."[77] Such indeed became the case, though the document's final disposition proved something of an inside job. As it turned out, Thomas B. Bryan, the art entrepreneur whose own building housed its exhibit, purchased it for $3,000. (By comparison, another coveted autograph document, Lincoln's proclamation on amnesty and reconstruction, sold at a Sanitary Fair in Cincinnati later that same month for only $150.)[78] Bryan was no stranger to Lincoln. The proprietor of a well-known gallery of presidential portraiture, he had commissioned the painter G. P. A. Healy to paint Lincoln from life in Springfield right after his 1860 election, then begged Lincoln to visit his quasi museum when the president-elect traveled to Chicago two weeks after his victory. Lincoln never showed up, claiming he could "not find leisure" to avail himself of "this Mr. Bryan's kindness," as he rather brusquely replied at the time.[79] Now the once-rejected suitor had surely made the president take notice.

Not only did the manuscript fetch a huge sum of money, it earned the president an unexpected and generous per-

sonal reward: a gold watch that had been donated by a local jeweler and earmarked for "the largest contributor" to the fair. "Thou art the man," Mary Livermore giddily informed him when the proceeds were counted. And for good measure, at Bryan's orders, his manuscript was to be framed and placed on display permanently, if not at the historical society, then on the wall of a soon-to-be-opened group home for old soldiers, where, she predicted, it would be "its cap-sheaff [sic] and glory . . . a lasting monument of your wisdom, patriotism, liberality, & fatherly tenderness."[80] The news delighted the reluctant donor. He was constrained by none of the potential public relations dangers or tax-reporting rules that might inhibit a modern, disclosure-minded president from accepting such a prize. Lincoln did so with "high appreciation," as he told the jeweler who sent it, "of your humanity and generosity, of which I have unexpectedly become the beneficiary."[81] He wore his gold emancipation watch for the rest of his life.

If the gift was truly unexpected, it was certainly the last time Lincoln would be surprised by Americans' eagerness to celebrate his Emancipation Proclamation, or at least its resonance as an icon, banal prose notwithstanding. Just one week before he received his gold watch, Chicago Republican J. J. Richards petitioned the president for a photographic copy of the proclamation, shifting Mrs. Livermore's Old Testament flattery to the New.

Richards maintained fulsomely that "this greatest work, of yours, or of any man, since our Saviors time,— *Cannot be in any house,* without inspiring the inhabitants therein, with its spirit of 'peace on earth & good will, to man.'" His own concession to goodwill would be to sell copies for two, three, or five dollars apiece, the low price structured to prevent those pleading "poverty" or "heavy taxation" from resisting yet another effort to raise funds for soldiers. Richards had evidently caught wind of the fact that Lincoln or his staff had made certain that photographic copies were made of the manuscript before he relinquished it to the Chicago fair. But he apparently also had heard of efforts already under way to reproduce it for "personal profit."[82] One example was produced by Chicago lithographer A. Kidder, who boasted to Lincoln that he had manufactured a copy "the taste and ingenuity of which have received the highest commendations of all artists who have seen it." Kidder begged Lincoln for an acknowledgment, which he vowed to treasure more than any "honors or emoluments or any other earthly favor," but if Lincoln obliged him with an endorsement, it has disappeared.[83]

Another entrepreneur who leapt into the trade was Benson John Lossing, a journalist and illustrator who also secured one of the photographs made of the final proclamation by U.S. Treasury photographer Lewis Walker before the manuscript was shipped to Chicago

for sale. In 1874, Lossing reproduced it in his three-volume pictorial history of the Civil War.[84]

Accusations of profiteering never stopped Thomas B. Bryan. By January 7, 1864, he had sent Lincoln proof copies of what he called a "lithographed Facsimile of your Proclamation of Freedom," asking him "to inform me if the copy impress you favorably as an exact Facsimile." A "share"—but *only* a share—of the profits would go to the new Chicago Soldiers' Home, and copies sold in the East would benefit the U.S. Sanitary Commission—that is, "net proceeds." Between the lines it can be inferred that Bryan believed his $3,000 investment for the original would first be recouped. Designed by printmaker Edward Mendel, complete with a lithographed portrait of the president based on a new photograph, the print featured a facsimile of Lincoln's transmittal letter to Mrs. Livermore, as well as a certification of authenticity by Bryan and Reverend Henry W. Bellows of the Sanitary Commission—accurate enough to move Lincoln to admit, "it impresses me favorably as being a faithful and correct copy."[85]

Around this very same time, early 1864, Lincoln received a request for the only other publicly known emancipation document still in his control. Again, the request came from a charity fair, and once more it took considerable political wire pulling to get the author to part with his work. This time the project was a bazaar modeled

after the Chicago event, managed by the Albany, New York, Army Relief Association. Open from February 22 through March 30, 1864, surely in the teeth of one of Albany's dread winters, the event nevertheless drew thousands of spectators to its barracks-like temporary structures in the New York state capital's Academy Park. The fair featured such attractions as international display booths, a "curiosity shop," a military trophy room, and even a perfumery. The magical setting, its special newspaper declared, had "risen like the palace of Aladdin."[86]

All that the "palace" lacked was a crown jewel. Though organizers planned to raffle off such items as a cuckoo clock and a Shaker doll, surely something more substantial was needed for the drawing, and the chairman of the fair's organizing committee, William Barnes, was uniquely placed to aspire to a far loftier treasure: the original manuscript of the preliminary Emancipation Proclamation. Though he never achieved a political station of his own higher than state superintendent of insurance, Barnes was married to the daughter of Thurlow Weed, the Albany editor and Republican political boss who for years had served as chief sponsor of one-time New York governor and senator William Seward, now secretary of state. Sidestepping the president, Mrs. Barnes appealed directly to her father's old friend. On January 4, Seward's son and assistant secretary, Frederick W. Seward—who had also witnessed the New Year's Day

signing at the White House—obliged by sending Mrs. Barnes "the original draft of the September proclamation," the "body" of the work "in his [Lincoln's] own handwriting."[87]

No doubt the president endorsed the donation, probably as a favor to Seward, though the decision to part with it surely pained him as much as losing the final proclamation: it was the last major, original freedom manuscript over which he had personal possession. Though he left no record of his thinking, it is reasonable to assume he may however have liked the idea of dispatching the treasure to a city whose Copperhead Democrats had only six months earlier bitterly denounced Lincoln for allegedly abusing his executive powers. The resolutions that Erastus Corning and others had issued, and the lengthy presidential reply they inspired, had been widely reported in the national press. Now Lincoln could add a compelling coda to his already famous letter by sharing his proclamation with the same town that had only recently vilified him as a tyrant.

Not surprisingly, the document's arrival sparked huge interest in the Albany fair, and organizers took maximum advantage of the publicity by delaying the raffle drawing until closing night. Ill-advisedly, however, they announced that for added drama the winning ticket would be drawn from a lottery wheel used in the city only recently for conscripting soldiers. Five thousand

raffle tickets were offered at one dollar each, but for a time, as would be the case in Philadelphia, sales languished. The resistance in Albany was perhaps attributable not only to the anti-Lincoln, pro-Corning element in town but also to the impolitic reminder of the unpopular military draft, which just recently had ignited race riots both in New York City and upstate. The fair's official newsletter did not help when it published a stunningly disobliging piece of doggerel that wickedly made this point. In the little publication created to promote the fair, not criticize its most generous donor, an anonymous rhymester joked: "The President sent in a Draft—; / What else could be expected, / From one who's dealt in nothing else / Ever since he was elected?"

Despite the brouhaha, William Barnes remained optimistic about selling the manuscript—even if it held for most others far less historical significance than the one recently sold at Chicago. As he gamely if unconvincingly insisted to the wealthy New York abolitionist Gerrit Smith, a member of the fair's organizing committee: "I think the 22nd Sept. is really more valuable than the 1st of Jany. . . . The *Judgment* was really pronounced in Sept. Jany. Was only enforcing *Execution*. The Sept. Proclamation first embodied the President's plan . . . was really the effective Proclamation of Freedom."[88]

The philanthropically minded Smith needed no further convincing. Although fair organizers reported flog-

ging all but eight of the remaining unsold tickets to the "absolutely stifling" crowd thronging the fair during its final hours on March 9, 1864, it appears that Smith, a man of considerable means, purchased a huge block of them for himself—perhaps as many as a thousand. It certainly increased his odds of winning, and win he did. Whatever concerns his success may have triggered about conflict of interest and overspending, a "loud and hearty cheer" reportedly greeted the announcement that the old abolitionist hero's name had been drawn from the converted draft wheel. According to William Barnes: "Everyone was satisfied and seemed better pleased than to claim it themselves." As he insisted in a somewhat unconvincing congratulatory letter to Smith: "The disposition of it although by chance is eminently just."[89]

In the days when presidents simply trusted the U.S. mails with their greatest documents, chance indeed influenced preservation. Just a few weeks after Gerrit Smith won his copy of the proclamation, a postmaster elsewhere in upstate New York sent Lincoln a copy of an extremely personal letter he had written his wife about their finances and their little son's lost pet goat. Somehow a soldier had found the letter and kept it, and only now was the "soiled" original being returned to sender. "Had it been a fragment of the Emancipation Proclamation," the postmaster admitted, it "would not probably have *thus* found its way back to the author."[90]

As it happened, Lincoln's two freedom documents made it through the nineteenth-century postal system without harm, but they ended up meeting startlingly different fates. The preliminary proclamation remained with Barnes in Albany at Gerrit Smith's suggestion, while Smith searched for another organization to which he might redonate it to generate still more money for the Sanitary Commission. At one time he considered offering it to what turned out to be the largest fundraising spectacular of them all, the Metropolitan Fair on Sixth Avenue at Fourteenth Street in New York in April 1864.[91] It was Barnes who discouraged him from doing so, arguing that it would expose the prize to "corruption or chance," ironically the very same charges that may have filled the air after Smith's "chance" success in the Albany bazaar raffle.

Although Smith passed formal title to his prize to the U.S. Sanitary Commission, Barnes, son-in-law of America's "Wizard of the Lobby," desperately lobbied the New York Assembly and State Senate to acquire it—but without initial success. The Legislature finally passed a bill purchasing the proclamation for $1,000, but not until partisan resistance eroded following Lincoln's tragic death and Albany's own funeral ceremony in his memory in April 1865. To this day, the precious document remains in the collections of the New York State Library, albeit all but petrified in a mammoth, vacuum-sealed

windowed steel case that resembles a bank safe more than a frame. Nonetheless, New York does deserve immense credit for rescuing the document from a devastating fire that swept through the state capitol building in 1911.

No such luck reigned in Chicago. There, Thomas Bryan made good on his promise to enshrine the final proclamation manuscript at the city's new Soldiers' Home. There it was on display, as Mary Livermore sadly remembered, when American history's best-remembered disaster struck town. In Mrs. Livermore's simple words, Lincoln's most famous manuscript "burned at the time of the great conflagration."[92]

As for the original, "official" engrossed copy of the document, it survives and lives permanently in the National Archives in Washington. But this copy is not in Lincoln's hand: it was composed in flourishing penmanship by an official government scribe and signed by Lincoln on New Year's Day 1863. It might have been issued earlier in the day, sparing the North's churchgoers from hours of anxiety and anticipation, had it not been for the fact that Lincoln proofread it scrupulously before his holiday reception. To his dismay, he found an error he felt made it impossible for him to sign the document first thing that morning: the engrossing clerk had mangled the standard postscript that had appeared on every presidential proclamation since Lincoln's very first order calling out the militia after the attack on Fort Sumter:

"In witness whereof, I have hereunto set my hand and caused the seal of the United States to be affixed."[93]

On the scroll first presented for Lincoln's signature on January 1, the words instead went: "I have hereunto set my *name*" (emphasis added). It was a small and inconsequential error, but Lincoln knew this document would be remembered, studied, and scrutinized—perhaps he even knew by then, judging by the early clamor for both advance texts and his pen, that it would be reproduced—and therefore insisted that it be perfect. His own precision must be reflected in the official copy. So it was returned and ordered reengrossed. Not until midafternoon, while many Americans waited in houses of worship, meeting halls, and private homes, did the president leave his public reception in the East Room, walk upstairs to his office, and join the trio of witnesses gathered there with the reengrossed document. Only then did he sign it, after which clerks affixed the Great Seal of the United States to it and attached the traditional ribbons. This is the legal copy, and while it survives, it is fading fast and thus almost never appears on public view anymore. Time has taken its toll—on its vanishing ink and perhaps, too, on its reputation—and it has also erased evidence that might testify to Lincoln's own, odd fear that his name might not appear bold enough to future generations. "The signature looks a little tremulous," he fretted to

Schuyler Colfax, "for my hand was tired, but my resolution was firm . . . and not one word of it will I ever recall."[94] By then the words themselves hardly mattered.

Three days before the end of 1862, Frederick Douglass began a speech at Zion Church by declaring: "This is scarcely a day for prose. It is a day for poetry and song, a new song." Yet he concluded his remarks by conceding that in a period of "malignant" racism and "hateful clamor for oppression of the Negro . . . [only] Law and the sword can and will in the end abolish slavery."[95] Douglass perfectly understood that Lincoln had not allowed himself poetry and song for fear his proclamation would not only prove ineffective but also perhaps incite Border State disloyalty, European intervention, judicial rejection, and political humiliation without achieving legal freedom for enslaved people.

The poetry came initially from others. One anonymous writer told African Americans: "Freedom's song / Breaks the long silence of your night of wrong." A poet named Barry Gray sent Lincoln a long celebratory ode "after reading his recent Proclamation," declaring: "He was ordained to do this Christlike deed, / To snap the bonds of slavery apart, / To break the chains which held the negro down, / And draw the iron from his bleeding heart." And no less authentic a bard of liberty than John Greenleaf Whittier ultimately said, as if further

blessing Lincoln's choice of language: "The mighty word /
He spake was not his own; / An impulse from the High-
est stirred / These chiselled lips alone."[96]

It must also be acknowledged that once legal dead-
lines passed, once Union regiments demonstrated that
they would continue fighting, once their ranks swelled
with new African American recruits, and once loyal slave
states remained so, Lincoln himself did in fact supply
the poetry his original order had lacked, providing
countless memorable expressions of his resolve and sin-
cerity that deserve to be read in tandem with his offi-
cial order.

At Gettysburg in November, for example, he famously
rededicated and reconsecrated the war to a "new birth
of freedom." No less dyspeptic a critic than Mencken
praised as "genuinely stupendous . . . the highest emo-
tion reduced to one graceful and irresistible gesture"—
in other words, poetry.[97] But three months earlier, Lin-
coln eloquently denounced anti-black sentiment in his
own Illinois hometown with a brave speech written for a
mass meeting of Springfield pro-Union men who op-
posed not only black recruitment but also black free-
dom. Conceding that his old neighbors "dislike the
emancipation proclamation," he bluntly told them that
"it can not be retracted, any more than the dead can be
brought to life." Black people, he added, "like other
people, act upon motives. Why should they do any thing

for us, if we will do nothing for them? If they stake their lives for us, they must be promoted by the strongest motive—even the promise of freedom. And the promise being made, must be kept." And then, for good measure, Lincoln offered a stinging, justly famous coup de grâce. Peace would come again, he hoped, proving once and for all that "there can be no successful appeal from the ballot to the bullet," whatever the cost. And then, in tribute to the thousands of black soldiers already fighting heroically in the ranks, Lincoln warned:

> And then, there will be some black men who can remember that, with silent tongue, and clenched teeth, and steady eye, and well-poised bayonet, they have helped mankind on to this great consummation; while I fear, there will be some white ones, unable to forget that, with malignant heart, and deceitful speech, they have strove to hinder it.[98]

Surely this is authentic freedom poetry—the "bleeding heart" pulsating beneath the "iron." No less a writer than Harriet Beecher Stowe called the Springfield letter the expression of "a mind both strong and generous," and concluded that Lincoln's words were "worthy to be inscribed in letters of gold."[99]

What remains the most impressive, intriguing, and maddening moment of any in the Lincoln canon came

just days before he issued his final proclamation. His annual message to Congress—the equivalent of today's State of the Union messages—contained the most baffling example yet of his propensity to juggle prose and poetry where freedom was concerned. On one hand, Lincoln proposed a ludicrous and heartless plan to colonize free blacks and delay compensated emancipation in the loyal slave states in some cases until the almost unimaginable year 1900. Yet at the end came soaring words surely meant as much for all Americans as for all of Congress:

> Fellow-citizens, *we* cannot escape history. . . . In *giving* freedom to the slave, we *assure* freedom to the *free*— honorable alike in what we give, and what we preserve. We shall nobly save, or meanly lose, the last best, hope of earth. . . . The way is plain, peaceful, generous, just—a way which, if followed, the world will forever applaud, and God must forever bless.

One newspaper promptly declared that these words should be "committed to memory and constantly recalled by every man."[100]

Finally, in March 1865, Lincoln took the oath of office for the second time by pledging "malice toward none" and "charity for all." But he preceded that merciful promise by insisting that "if every drop of blood drawn with

the lash, shall be paid by another drawn with the sword, as was said three thousand years ago, so still it must be said 'the judgments of the Lord are true and righteous altogether.'" Here at last was Old Testament righteousness worthy of John Brown.

In his painfully inconsistent 1862 annual message, Lincoln had strongly urged: "We must disenthrall ourselves." Perhaps the same trance breaking is required in order to properly reevaluate the Emancipation Proclamation.[101] It grows increasingly and dangerously tempting to view the proclamation from the vantage point of the twenty-first century, from which perspective we cannot help concluding only that it was delayed, cold, insincere, halfhearted, and uninspiring. But such judgment encourages our looking at history from the comparatively enlightened future backward, not from the past forward. And diagnoses from ever-widening distances unavoidably distort history.

In truth, the mere fact that Lincoln composed a legally coherent, if prosaic, Emancipation Proclamation in the face of such deeply felt personal, constitutional, political, diplomatic, and military uncertainty seems remarkable enough. That he crowned its prose with poetry in the months that followed seems genuinely astonishing. And that many Americans clamored for the freedom documents as holy grail testifies more eloquently to its impact than most of the quibbling observations of

his era, or ours. As his contemporaries sensed long before Richard Hofstadter made its reticence a vice, the document that appeared to have no more moral grandeur than a bill of lading safely launched its human cargo toward liberty after all.

Even while he was still writing the Emancipation Proclamation, Abraham Lincoln told Senator Charles Sumner: "I know very well that the name which is connected to this act will never be forgotten."[102] Lincoln was right. Among enlightened men and women of his age, at charity events calculated to consecrate the sacrifices made by its fighting men in freedom's behalf, that proclamation became iconic, its surface banality and asphyxiating legalese notwithstanding. A century and a half later, just as Lincoln predicted, much as we continue to debate the proclamation, we still remember its author.

What is more, convincing new evidence suggests that many Americans, black and white alike, may be renewing their reverence for the actual document as well, manifesting the same degree of enthusiasm that visitors to the nation's sanitary fairs demonstrated a century and a half earlier. In June of 2011, the National Archives briefly lent to the Henry Ford Museum in Dearborn, Michigan, the original engrossed copy of the Emancipation Proclamation—the official document that Lincoln signed on New Year's Day 1863. More than 3,500 people lined up around the clock for as many as eight hours for

a brief glimpse of the faded original, many of them African American. As U.S. Court of Appeals Judge Damon Keith explained after viewing the document: "It's precious.... I say this with all humility. My grandfathers on my mother and father's side were both slaves. This document has special meaning to me because it allowed them their freedom." When another inexhaustible visitor, seventy-three-year-old retired teacher Amy Jackson, was asked whether the long line might prove too daunting, she replied: "I can handle this. It's not as long as slavery."[103]

3

SACRED EFFIGIES

The scene was wild and grand. Joy and gladness exhausted all forms of expression, from shouts of praise to joy and tears." That was how Frederick Douglass described the moment when the words of the Emancipation Proclamation finally arrived over the telegraph wires on January 1, 1863. As he had written in a similarly jubilant mood three months earlier, when Lincoln first announced his emancipation policy: "We shout for joy that we live to record this righteous decree."[1]

Certainly the word *joy* could not describe the reigning mood at the White House ceremony at which Lincoln actually signed the document that Douglass and others first celebrated on that momentous holiday afternoon. In fact, calling it a ceremony at all would constitute an exaggeration; that it lacked emotion or fanfare of any kind is beyond dispute. All Lincoln did that day was quietly slip away from a long New Year's reception in the East Room and walk upstairs to his office to affix his name to the document in almost total privacy. More-

over, he maddeningly took his time to do so, delaying his formal action for hours even as the nation waited anxiously for the fulfillment of a promise on which many people were absolutely convinced he would renege. It did not help relieve tensions that the holiday began, and continued well past midday, without any definite word from Washington. "Will Lincoln's backbone carry him through?" wondered apprehensive New York diarist George Templeton Strong. "Nobody knows."[2]

Lincoln knew—he just kept his intentions to himself. But as he had confided to his wife, who argued that he should indeed refuse to sign the order, it was too late to waver: he was "a man under orders" from God to approve it.[3] Perhaps just as formidably, he was also under orders from the First Lady to keep his promise to host their annual East Room New Year's levee without interruption. For a time, Mrs. Lincoln's influence proved the more powerful, especially after the sharp-eyed Lincoln noticed an imperfection in the hand-engrossed copy prepared by a scribe and brought to him for his signature earlier in the day.[4] Lincoln sent it back to be recopied and joined the holiday levee as scheduled. Observing him there, one journalist noted: "The President seemed to be in fine spirits and cracked an occasional joke."[5]

Not for hours more did Lincoln make his way back to his office to review and at last "set his hand" to the freshly reengrossed document that Americans had expected him

to authorize hours earlier. It was now past 2:00 P.M. But even then Lincoln hesitated, not because he harbored doubts, he insisted, but because he felt physically weak. His fingers seemed "almost paralyzed," he complained, from so many hours of handshaking. Only when his circulation revived did he take up his pen, boldly write out his full name—"Abraham Lincoln"—and smilingly declare: "That will do."[6]

Lincoln immediately believed this to be not only the most important act of his presidency but "the great event of the nineteenth century."[7] And yet no artist or photographer was on hand to record an occasion he sensed from the outset would make him immortal. Nor did any of the few witnesses in the room—his two private secretaries, along with Secretary of State William H. Seward and Seward's own personal aide (his son)—leave detailed accounts for a hungry public of what the momentous occasion was like. In the end, this private ceremony, notwithstanding its enormous political and historic consequences, proved a delayed, modest, and private affair—an almost anticlimactic one—whose huge visual potential was totally lost. And these factors help explain the immediate impact, or more accurately the lack of it, that the proclamation exerted on artists, their publishers, and their customers in 1863.

Yet Lincoln's maddening informality that New Year's Day does not alone explain the surprisingly muted and lethargic artistic response to an event so consequential

to society and history, given the fact that his decision
two years earlier merely to grow whiskers had inspired
dozens of commemorative portraits.[8] The explanation
for the comparative scarcity of equally timely emancipa-
tion tributes is far more complicated and involves com-
mercial uncertainty, political timidity, and, inevitably,
the issue of race.

In the end, the arguments that speak far louder than
words on the subject of iconography are the surviving
images themselves: the popular prints, paintings, and
sculpture that eventually did appear to commemorate
emancipation. To understand their power, and their lim-
its, in the nineteenth century one need look no further
than a speech by Boston mayor Frederick O. Prince on
the occasion of the dedication there of a full-size replica
of Thomas Ball's large statue of Lincoln as emancipator.
To Prince, there was no doubt that such images were
required to best evoke the power of Lincoln's hold on
the popular imagination.

The historic page informs only the student and the let-
tered; but all can read and understand, with more or
less appreciation, the language of art. The popular mind
comprehends more readily an idea in the concrete than
the abstract,—an idea expressed by sensuous forms than
by words, however eloquent. Art perpetuates its highest
office when it perpetuates heroic action. National monu-

ments are epic lessons to future generations, they instruct, admonish, delight, and inspire. That which we dedicate today speaks of the most important act in our annals, and commemorates one of the great eras of the Republic,—the *emancipation of four millions of slaves.*[9]

However earnest, Prince's comments, it should be noted, came at an event that took place nearly seventeen years after Lincoln first signed the proclamation. Not surprisingly, the speaker made no attempt to explain the slow and limited artistic response that first greeted the order. Nor did Prince acknowledge that it took widespread public grief over Lincoln's death to truly animate the image of Lincoln as the Great Emancipator. When it was ultimately introduced, that image, however simplistic, endured in American iconography for a remarkably long time, although it would eventually undergo deconstruction, revision, and, one might argue, yet another more recent revival. Nevertheless, it is crucial to remember that such pictures did not proliferate at all in the months after Lincoln's newsworthy thunderbolt was announced.

Parenthetically, some of the images reproduced on these pages serve to "illustrate" the previous two chapters—but in their own day, they were *not* merely illustrations as we later came to know the term: that is, they were not pictures orchestrated merely to accompany text. Rather, they

were independent, stand-alone visual creations, specifi-
cally produced for audiences passionately eager both to
install large ones in places of honor in civic settings and
to display smaller, more affordable versions in the sacred
domestic realm of the American home to signal their own
political and patriotic convictions. The latter category
embraces the once wildly popular genre of display prints,
both fine engravings and less-expensive lithographs.
Though some of them may look contrived, crude, oversim-
plified, or racially stereotyped to modern eyes, in their day
they were symbols of genuine progressivism or, alterna-
tively, totems of fierce opposition to Lincoln and his poli-
cies. In terms of both their ubiquity and the meaningful
places they occupied, they evolved into secular icons in the
American parlor. And since they were entirely the creations
of commercial entrepreneurs, their appearance almost al-
ways reflected prevailing public taste. They were not com-
missioned by politicians to influence public opinion. They
were created by businessmen to meet public demand.

Until emancipation, nearly all major wartime events
routinely inspired rapid graphic treatment for news
value alone, however dependent printmakers were on
original sources such as photographs, sketches, or paint-
ings as models. There was commercial benefit to time-
liness. After all, the printmaker who was the first to
advertise a new picture of a newsworthy event could rea-
sonably anticipate popular success among audiences for

whom engravings and lithographs were the major source of pictorial reportage. Yet few printmakers rushed into the marketplace on the subject of emancipation, and this suggests that the theme at first struck picture publishers as too controversial to qualify for home decor. Of course, emancipation models were for a time scarce or uninspiring. It was certainly no fault of the artists that Lincoln had failed to summon image makers to his January 1, 1863, signing ceremony, much less provide the kind of heroic scene—what historians call an "emancipation moment"—to inspire such renderings quickly.[10]

But the initial scarcity of visual tributes marks emancipation as unique among all the turning points of the war—at least as the graphic arts saw it—in its failure to inspire such depictions. And this raises a question: aside from lack of access to the White House signing ceremony and uncertainty about who might purchase such tributes, why else were there so few emancipation images for so long?

For one thing, artists may have had difficulty in interpreting its numbing, uninspiring words, particularly while their actual impact remained uncertain. After all, the document promised, but did not deliver, immediate freedom to large numbers of enslaved people—at least, not until Union armies could win victories in the Confederacy and liberate slaves in their wake. Even in the case of the decorative reprint placed on display in the 2010

Obama White House there can be no denying the prosaic text of the proclamation itself and the blandness of this now famous and initially unsuccessful signed Leland-Boker reproduction.

A few early printmakers did attempt to introduce decorative accoutrements to enhance the appeal of their own reproductions, but to modern eyes these tentative results seem absurdly clumsy or embarrassingly clichéd. To set apart one elaborately handwritten redesign, for example—crafted "entirely with steel pens and writing inks," its caption boasted—artist Joseph Paine placed artistic-license emphasis on the all-capitalized word "FREE" within the text and used it to crown a clunky visual metaphor suggesting the proclamation had blossomed from the biblical tree of life.[11] The effort might have been more convincing had it featured a Lincoln portrait that captured his actual appearance in 1863. Instead, the artist inexplicably adopted an outdated 1860 pose that showed the president without his familiar beard. Nonetheless, in a period when any tributes were scarce, Paine sold his for the grand sum of $500 at the 1864 Brooklyn Sanitary Fair, and then proudly sent a copy as a keepsake to Lincoln himself.[12]

For another early, lithographed emancipation, a printmaker reproduced the text directly from the signed manuscript of the proclamation that Lincoln had sent to Chicago for the Great Northwestern Sanitary Fair.

The local art impresario who purchased it there, Thomas
B. Bryan, ordered the original reproduced, added an
outdated photograph of Lincoln as he had looked back
in Illinois before his inauguration, and then dispatched
a proof copy to the president, accompanied by the vow
that profits from its sale would go to war charity.[13] No
doubt aware that his endorsement might generate in-
creased revenues for the cause, Lincoln generously de-
clared the "lithographed facsimile," as he called it, "a
faithful and correct copy."[14] What the printmaker, the
patron, the public, and the president surely noticed,
however, was that no African Americans appeared in the
composition even though the document itself had prom-
ised to dramatically change their lives. When another
printmaker named A. Kidder sent his own freehand
adaptation of the proclamation to Lincoln, he boasted
that "every American citizen" would "place it among his
household gods and teach their children how you deliv-
ered from bondage a nation in a day."[15] But Kidder's ef-
fort was similarly bereft of memorable cause-and-effect
imagery. With no more than these mediocre interpreta-
tions immediately available, it is no surprise that Ameri-
can citizens and the image makers who supplied their
pictures did not immediately place the emancipation or
its author among their "household gods."

In another example of the genre, published in Milwau-
kee by lithographers Martin and Judson a full year later,

African Americans did finally earn a place in the visual story. But they were relegated to the sidelines, seen in a series of miniature before-and-after vignette portraits running from top to bottom on either side of the proclamation's text. At left, they were depicted as suffering under the oppressive yoke of slavery; at right, by comparison, they were portrayed as enjoying the benefits of freedom—working (albeit in the same old cotton fields), attending school, and enjoying family life at home. The message was coming into focus at last—the actual, if limited, impact of emancipation as imagined by white artists. And in nearly all these initial, tentative efforts to commemorate emancipation in popular prints, black Americans were emphatically not created equal. More than fifty such publications, plain and embellished alike, appeared in 1863 and 1864, but the overwhelming number were mere reproductions of or exquisitely penned calligraphic renditions of its legalistic words, and while a few included portraits of Lincoln, most artists seemed chronically reluctant to focus the attention of the white customer on precise visualizations of black freedom.[16] After all, what assurance could they have that white customers would purchase such prints for display in their homes?

A clue to what Lincoln himself thought of the early examples of florid emancipation calligraphy, which emphasized penmanship over interpretation, could be

found in a revealing remark he made to a visiting painter after being shown yet another variation on the theme, this one boasting no fewer than 721 words and 38 distinct miniature illustrations (Lincoln's portrait merely a tiny cameo). Although its publisher proudly dubbed it "the great novelty of the age" and an "elegant historical memorial," the president himself regarded it as an example of what he termed *"ingenious nonsense."*[17] Perhaps he had ample reason for skepticism. Another similarly misguided image of the day showed a disproportionately gigantic Lincoln clutching the proclamation in his hand astride a "chain of African slavery" that lay "sundered beneath his feet." Its creator, A. James of Chicago, proudly claimed that he had crafted the clumsy original drawing "while in a trance condition."[18]

The results were more ambitious, but only marginally more distinguished, when notable artists first undertook to tackle the emancipation theme. Here, too, hesitation and ambivalence marred these initial tributes. Thomas Nast, a pro-emancipation, pro-administration artist if ever there was one, demonstrated considerable uncertainty with a woodcut engraving that appeared in *Harper's Weekly* only a few weeks after Lincoln announced his final proclamation. Though the print celebrated the concept of emancipation enthusiastically and depicted

African Americans as its beneficiaries, it suggested in its vignette illustrations that Lincoln's order would transform ex-slaves only into reliable paid laborers—daring to suggest no higher aspirations to a potentially wary white audience. Not until 1865 did Nast update his two-year-old woodcut into a version that more directly honored Lincoln, whose image did not even appear in the *Harper's* original.

Also in 1863, the liberally minded German-born painter David Gilmour Blythe crafted a sympathetic composition showing Lincoln writing the proclamation in what appeared to be his nightshirt—probably meant to suggest the apparel of the frontiersman. Unfortunately, Blythe's picture was so overwhelmed by symbolic accoutrements that, judging by their rarity, lithographed adaptations failed to find a significant audience among proponents of freedom or admirers of Lincoln.[19] That same year, however, Republican leaders in Philadelphia dispatched one of the city's most distinguished portrait artists, Edward Dalton Marchant, to create a canvas of Lincoln as emancipator to grace the walls of Independence Hall. No doubt flattered by the prospect of such a tribute—after all, en route to his inauguration Lincoln had visited the hallowed building and grandly declared, "I would rather be assassinated on this spot than to surrender it"[20]—the preoccupied president obligingly threw open the doors of the White House and made himself

BY THE PRESIDENT OF THE UNITED STATES OF AMERICA.

A Proclamation.

Whereas, on the twenty-second day of September, in the year of our Lord one thousand eight hundred and sixty-two, a proclamation was issued by the President of the United States, containing, among other things, the following, to wit:

"That on the first day of January, in the year of our Lord one thousand eight hundred and sixty-three, all persons held as slaves within any State or designated part of a State, the people whereof shall then be in rebellion against the United States, shall be then, thenceforward, and forever, free; and the Executive government of the United States, including the military and naval authority thereof, will recognize and maintain the freedom of such persons, and will do no act or acts to repress such persons, or any of them, in any efforts they may make for their actual freedom.

"That the Executive will, on the first day of January aforesaid, by proclamation, designate the States and parts of States, if any, in which the people thereof, respectively, shall then be in rebellion against the United States; and the fact that any State, or the people thereof, shall on that day be in good faith represented in the Congress of the United States, by members chosen thereto at elections wherein a majority of the qualified voters of such State shall have participated, shall, in the absence of strong countervailing testimony, be deemed conclusive evidence that such State, and the people thereof, are not then in rebellion against the United States."

Now, therefore, I, ABRAHAM LINCOLN, PRESIDENT OF THE UNITED STATES, by virtue of the power in me vested as commander-in-chief of the army and navy of the United States, in time of actual armed rebellion against the authority and government of the United States, and as a fit and necessary war measure for suppressing said rebellion, do, on this first day of January, in the year of our Lord one thousand eight hundred and sixty-three, and in accordance with my purpose so to do, publicly proclaimed for the full period of one hundred days from the day first above mentioned, order and designate as the States and parts of States wherein the people thereof, respectively, are this day in rebellion against the United States, the following, to wit: ARKANSAS, TEXAS, LOUISIANA, (except the Parishes of St. Bernard, Plaquemines, Jefferson, St. John, St. Charles, St. James, Ascension, Assumption, Terre Bonne, Lafourche, St. Mary, St. Martin, and Orleans, including the City of New Orleans,) MISSISSIPPI, ALABAMA, FLORIDA, GEORGIA, SOUTH CAROLINA, NORTH CAROLINA, AND VIRGINIA, (except the forty-eight counties designated as West Virginia, and also the counties of Berkeley, Accomac, Northampton, Elizabeth City, York, Princess Ann, and Norfolk, including the cities of Norfolk and Portsmouth,) and which excepted parts are for the present left precisely as if this proclamation were not issued.

And by virtue of the power and for the purpose aforesaid, I do order and declare that all persons held as slaves within said designated States and parts of States are and henceforward shall be free; and that the Executive government of the United States, including the military and naval authorities thereof, will recognize and maintain the freedom of said persons.

And I hereby enjoin upon the people so declared to be free to abstain from all violence, unless in necessary self-defence; and I recommend to them that, in all cases when allowed, they labor faithfully for reasonable wages.

And I further declare and make known that such persons, of suitable condition, will be received into the armed service of the United States, to garrison forts, positions, stations, and other places, and to man vessels of all sorts in said service.

And upon this act, sincerely believed to be an act of justice warranted by the Constitution upon military necessity, I invoke the considerate judgment of mankind and the gracious favor of Almighty God.

In witness whereof I have hereunto set my hand and caused the seal of the United States to be affixed.

[L. S.] Done at the City of WASHINGTON this first day of January, in the year of our Lord one thousand eight hundred and sixty-three, and of the Independence of the United States of America the eighty-seventh.

By the President: *Abraham Lincoln*

William H. Seward Secretary of State.

A true copy, with the autograph signatures of the President and the Secretary of State.

Jno. G. Nicolay
Priv. Sec. to the President.

By the President of the United States: A Proclamation. Election-year souvenir broadside of the Emancipation Proclamation, published in 1864 in Philadelphia by Charles G. Leland and George H. Boker, Frederick Lypolt, printer. (Courtesy Sotheby's)

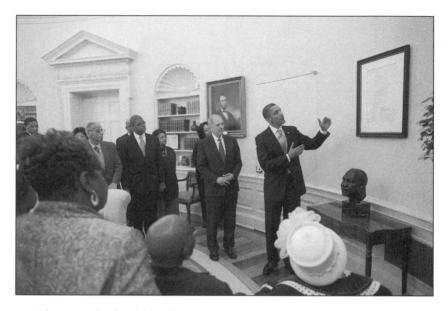

President Barack Obama displays the so-called Leland-Boker edition of the Emancipation Proclamation to civil rights veterans in the Oval Office of the White House, on January 28, 2010. (White House Photograph)

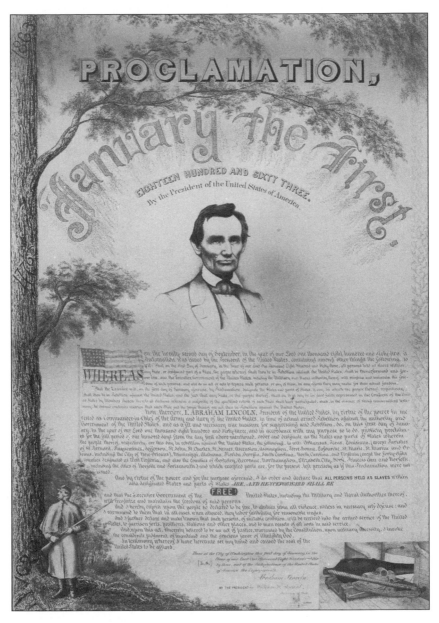

Although outdated, an 1860 photograph of a beardless Lincoln by Mathew B. Brady inspired this 1864 lithographic tribute, *Proclamation*. (Indiana Historical Society)

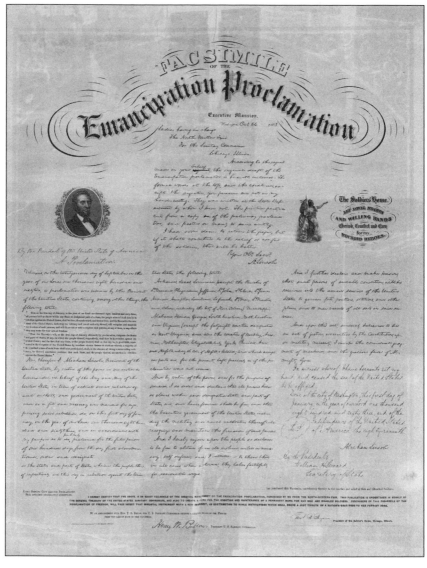

Featuring a Lincoln portrait based on an 1861 photograph of Lincoln made back in Springfield by C. S. German, this *Facsimile / of the / Emancipation Proclamation* offered a precise replica of the handwritten document that Lincoln donated to a Chicago charity fair. Broadside, published by Thomas B. Bryan, 1863. (Library of Congress)

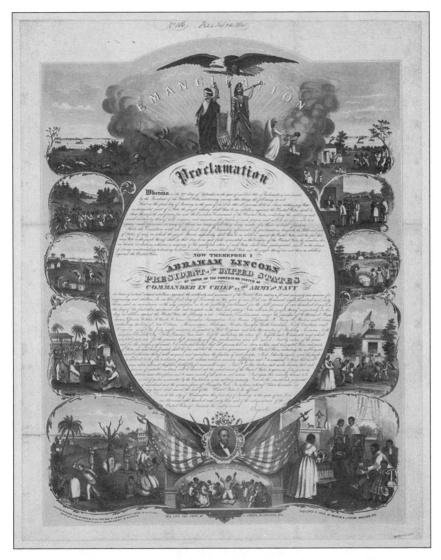

Like many emancipation broadsides, this 1864 lithographic replica of the proclamation became a campaign piece for the 1864 presidential election. It was created by L. Lipman, after an 1860 photograph of Lincoln by C. S. German, published by S. W. Martin and N. P. Judson, Milwaukee, 1864. (Wisconsin Historical Society)

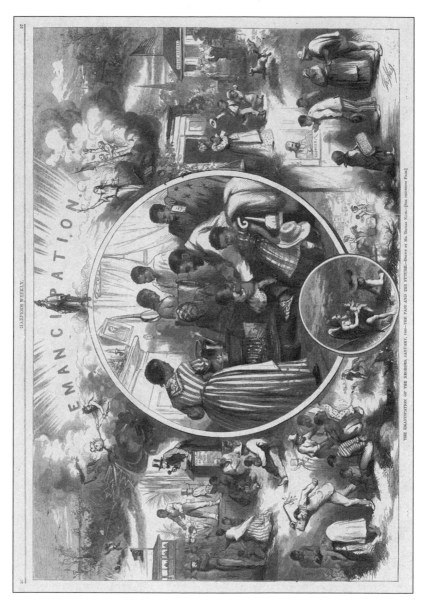

One of the most widely seen pictorial commentaries on the proclamation, Thomas Nast's (1840–1902) woodcut engraving, *Emancipation*, was published in the popular *Harper's Weekly* on January 23, 1863. (Library of Congress)

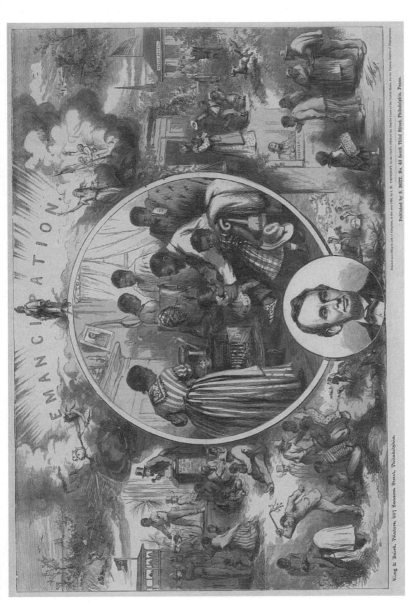

Nast's original and an 1864 Lincoln photograph by Mathew Brady's gallery inspired this display adaptation of the *Harper's* original. Lincoln is now featured prominently. This large woodcut version of *Emancipation* was published by S. Bott in Philadelphia after Lincoln's death in 1865. (Library of Congress)

Edward Dalton Marchant's (1806–1887) oil painting, though based in part on an 1861 photograph, probably by the Brady studio, was the result of life sittings at the White House. Lincoln posed for the 1863 picture believing it would be displayed in Independence Hall. (The Abraham Lincoln Foundation of the Union League of Philadelphia)

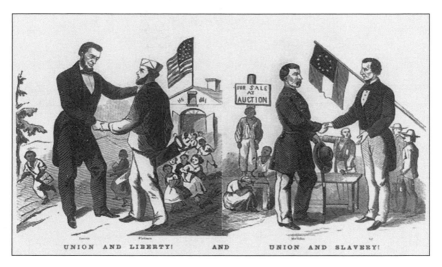

UNION AND LIBERTY! AND UNION AND SLAVERY!

The unknown artist of the engraved cartoon *Union and Liberty! And Union and Slavery!* contrasted a future of freedom and education under Lincoln to one of slavery and intolerance under his presidential rival, George B. McClellan. The 1864 campaign print was published by M. W. Siebert in New York in 1864. (Library of Congress)

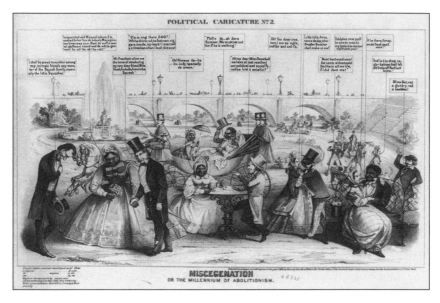

The pro-Democratic, anti-Lincoln *New York World* was responsible for a series of race-baiting campaign cartoons in 1864, the most famous of which is *Miscegenation / or the Millennium of Abolitionism*, lithographed by Bromly & Co. in New York in 1864. (Library of Congress)

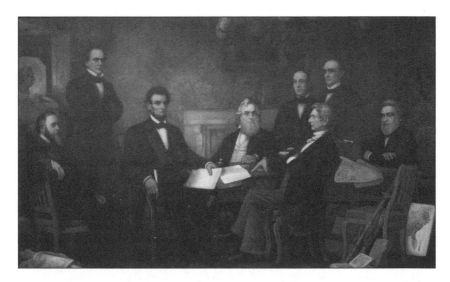

Francis Bicknell Carpenter (1830–1900), after 1864 photographs by the Mathew Brady gallery and sketches and oil studies from life, *The First Reading of the Emancipation Proclamation of President Lincoln.* Oil on canvas, 1864. This acclaimed, giant canvas was exhibited nationally before finding a permanent home in the Capitol. (U.S. Capitol Collection; photograph courtesy Library of Congress)

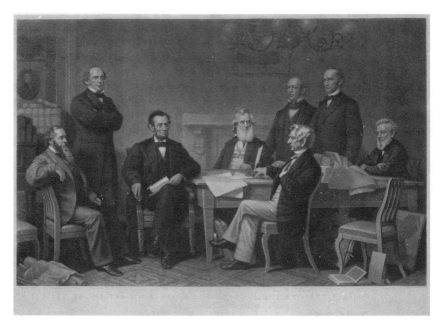

Perhaps the most popular political print of the entire nineteenth century, Alexander Hay Ritchie's engraving of Carpenter's painting, retitled *The First Reading of the Emancipation Proclamation before the Cabinet*, published by Derby and Miller of New York in 1866, remained a best-seller for three decades. (Library of Congress)

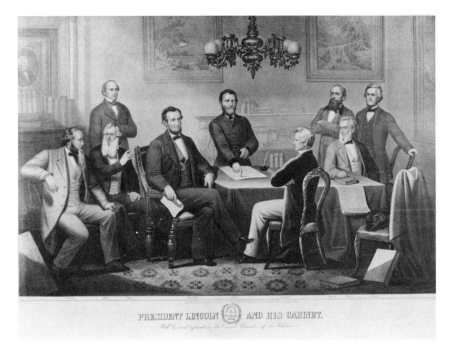

PRESIDENT LINCOLN AND HIS CABINET.
With Genl Grant in the Council Chamber of the Whitehouse

The Carpenter-Ritchie collaboration inspired many thinly disguised piracies, including New Yorker Thomas Kelly's 1866 lithograph, *President Lincoln and His Cabinet. / With General Grant in the Council Chamber of the Whitehouse.* (From The Lincoln Financial Foundation Collection, courtesy of the Indiana State Museum)

JEFFERSON DAVIS AND HIS CABINET.
With General Lee in the Council Chamber at Richmond.

The most outrageous Carpenter "knockoff" was undoubtedly Kelly's *Jefferson Davis and His Cabinet. / With General Lee in the Council Chamber at Richmond*, also published in 1866, which mindlessly placed the "proclamation" in the hands of the former president of the Confederacy! (Library of Congress)

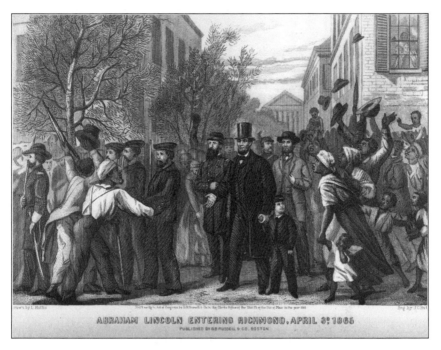

ABRAHAM LINCOLN ENTERING RICHMOND, APRIL 3d 1865

PUBLISHED BY B.B.RUSSELL & CO. BOSTON.

Though no artist witnessed Lincoln's emotional encounter with newly freed African Americans on the streets of Richmond near the end of the Civil War, artist L. Hollis's interpretation mirrored contemporary reports. It was adapted by J. C. Buttre for the engraving *Abraham Lincoln Entering Richmond, April 3d. 1865*, published by B. B. Russell and Co., Boston, 1865. (Author's collection)

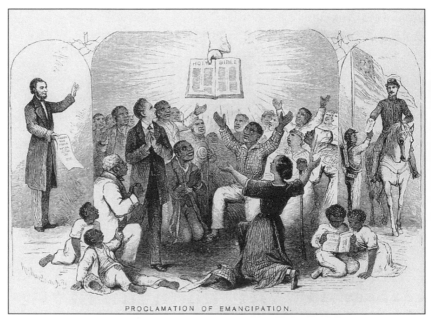

PROCLAMATION OF EMANCIPATION.

An artist known only as Richardson saw the *Proclamation of Emancipation* as a literal gift from the hand of God. This woodcut engraving was published in New York around 1865. (Author's collection)

available for three months of sittings beginning in early 1863.

Marchant intended to create what he called an "intellectual portrait" of Lincoln but was frustrated to find him "the most difficult subject who ever taxed" his talents—chronically reluctant to sit still, his elastic features vexingly shifting with his changing moods. As the artist later remembered, as if to excuse his finished canvas, Lincoln certainly looked heroic enough; it was just hard to paint him that way.

> Our worthy, noble, and heroic President has little of the grace of the Apollo, or the Antinous [Hadrian's famously handsome Roman page, the inspiration for many portraits], so desirable for pictorial purposes, as all the world knows. But if the man can be found, who, on seeing Mr. Lincoln when his feelings are stirred by emotion, or touched with some grand moving theme, or remarkable event will say he cannot see intense feeling, great intellectual power, and the boldest decision of character, beaming from his salient but manly features, I must say that I shall be sorry for all three of us.[21]

Marchant may have ended up as sorry as he feared. Notwithstanding his precious chance to capture Lincoln from life, he ultimately based his finished portrait on an outdated two-year-old photograph and portrayed

the president in an uncharacteristic formal white tie, gripping an outdated feathered quill to sign the proclamation as the chains on a statue of liberty symbolically snap in the background. The canvas never did earn its promised display at the nation's shrine to its independence. But Philadelphia engraver John Sartain produced a handsome engraved adaptation that came out in time for the 1864 presidential election and proved a useful campaign display piece in always crucial Pennsylvania. Marchant's effort may thus rank as the first broadly circulated Emancipation Proclamation tribute to Lincoln, achieving this status chiefly by deemphasizing the writing and instead focusing on the writer. Judging solely by the number of surviving copies, not to mention the subsequent authorized and unauthorized editions that soon followed, the print adaptation proved quite popular. Yet by then, it should be remembered, nearly two years had elapsed since the proclamation first took effect, during which time no other major emancipation tributes had appeared.

The Marchant-Sartain image proved a unique exception, at least for a time longer. Most other 1864 campaign graphics, especially of the pro-Lincoln variety, sidestepped the issue of emancipation and focused instead on vaguer notions of military victory and national prosperity. One exception, a lithographed cartoon by M. W. Siebert of New York, compared the comforting

prospect of "Lincoln & Liberty" (illustrated by vignettes showing education for freedmen, but with particular emphasis on new opportunities for the white "workman") to the retrograde prospect of "Union & Slavery" under Democratic candidate George B. McClellan (shown consorting with Confederate president Jefferson Davis as blacks return to the auction block). Significantly, both of Siebert's visions of the future relegated blacks to the background. Since they had uncanny commercial instincts, such printmakers' reluctance to emphasize emancipation during the presidential campaign, at least in posters designed for Republican audiences, suggests that the policy simply still boasted too few white proponents to guarantee a wide and profitable audience for pictorial tributes.

Not so for the opposition. Democrats fought back with such a vengeance on the subject that, for most of the 1864 campaign, foes of the administration were far more likely to buy emancipation prints (albeit of the negative variety) than supporters. Where occasional pro-emancipation graphics avoided the issue of race relations entirely, or suggested no more than a continuation of African American subservience, anti-emancipation prints bluntly countered that Lincoln's executive order would make blacks the equal of whites and upend American life. One particularly racist lithograph produced under the direct supervision of the anti-Lincoln *New York World,* for

example—rare in this age of commercially driven printmaking—accused Lincoln of favoring the then radical idea of intermarriage. The *World's* salacious lampoon *Miscegenation* showed Lincoln bowing subserviently to a derisively rendered mixed-race couple while supposedly disgusting scenes unfold nearby, including black men in public embraces with white women and, in the background, a white liveryman driving a black passenger in a carriage. The openly racist *New York Weekly Day-Book* recommended of the print: "It ought to be circulated far and wide as a campaign document."[22]

The nineteenth-century image maker who deserves credit for depoliticizing, indeed transforming, Emancipation Proclamation iconography was painter Francis B. Carpenter. By removing African Americans entirely from his planned celebratory tribute to emancipation, he ironically did more than any other artist of his day to elevate the image of both the proclamation and its author. The upstate New York anti-slavery artist determined to paint not the signing of the document but the first reading of its earliest (later discarded) incarnation by the president to his cabinet five months earlier. It was this early event, Carpenter insisted, not the signing of the final text, that best demonstrated "how a man may be exalted to a dignity and glory almost divine, and give freedom to a race."[23] A keen judge of the American audience, Carpenter embraced hero worship but not allegory.

He favored pomp over personality (his idea of a great moment in history was a stilted group portrait), preferred realism to symbolism, and eagerly employed the modern technology of photography to support his vision. Singularly, Carpenter would not merely turn to photographs as a crutch, as did the frustrated Marchant before him, but would manipulate the medium to his will by commissioning camera portraits of Lincoln assuming poses that the painter intended to reproduce in oil.

The artist meant his depiction of the July 1862 cabinet meeting (at which emancipation, truth to say, was tabled, not promulgated) to extol "that band of men, upon whom the eyes of the world centered as never before upon matters of state, gathered in council [with] the head of the nation bowed down with his weight of care and responsibility, solemnly announcing, as he unfolded the prepared draft of the Proclamation, that the time for inauguration of this policy had arrived."[24] When the skeptical *Philadelphia Daily Age* got wind of Carpenter's plan, it chortled:

> What a subject for artistic genius! What a field for color, for costume, for *pose,* for *chiaro-oscuro* [sic], for drapery, for light, for rendition of passion and emotion! The President, with his feet on the round of the chair hugging his long knees ... [Salmon] CHASE, with one hand on his breeches pocket [a reference to his management of the

Treasury Department] and the other side of his counte-
nance expressing disgust at the "two" term principle [an
allusion to his rumored plot to win the 1864 presidential
nomination] . . . [Attorney General Edward] BATES wak-
ing up, after three years of torpor, to the fact of an
increasing military power . . . [Navy Secretary Gideon]
WELLES fast asleep, with an "intelligent contraband"
brushing the flies off him. . . . With A. LINCOLN for the
central figure, Mr. CARPENTER will doubtless produce a
picture worthy of the costliest frame.[25]

Undiscouraged by such mockery, and apparently ea-
ger to see a worthy emancipation painting produced at
last, Lincoln turned Carpenter "loose" inside the White
House beginning in February 1864, giving him the run
of the premises and double the time he had allocated to
Marchant, a total of six months. Access notwithstand-
ing, Carpenter, like Marchant, quickly came to realize
that Lincoln would not grant him lengthy sittings, ei-
ther; he would have to paint him "on the jump."[26] So
the painter invited one of Mathew Brady's camera oper-
ators to the White House to record Lincoln inside his
second-floor office, marking the first time a president
ever posed for a photograph at the executive mansion.
The results were fuzzy, so Carpenter also took Lincoln
to Brady's better-lit gallery on Pennsylvania Avenue,
and there supervised a number of superior poses cre-

ated on February 9, 1864. After producing lively oil sketches of all the cabinet members, along with a muddier one of the president, clearly the most challenging of the subjects he painted, the meticulous Carpenter then made elaborate pen sketches of the entire group and finally adapted all these preliminary efforts into a giant canvas. When completed, it went on exhibit for the first time in the East Room, where Lincoln praised it effusively, or so the artist remembered, calling it "as good a piece of work as the subject will admit of," adding, no doubt with one eye on history, "I am right glad you have done it."[27] The *New York Evening Post* went further, gushing that Carpenter had "achieved a success which time will go on ripening to the latest day that Americans honor the nobility of their ancestors."[28]

Lincoln's signature on a surviving order book for the very first fifty-dollar proof copy of the planned engraved adaptation testified to his early enthusiasm.[29] But he never got to see the finished steel engraving by Alexander Hay Ritchie. Carpenter was a chronic reviser of his own work and proved unable to provide the necessary smaller copy for adaptation until 1866, the year after Lincoln's death. Largely because of his delay, Carpenter lost much of the immediate credit he deserved for this undertaking. Ironically, the painting at first earned only a brief early display in the U.S. Capitol, where the artist hoped it would be permanently housed. Not until 1878 was this

behemoth of a canvas purchased for its permanent collection. Even then it was not placed in the Capitol Rotunda, as the artist dreamed. Like Marchant before him, Carpenter painfully learned of the unstated but unmistakable reluctance that still inhibited the display of emancipation paintings alongside portraits from the Revolution in government buildings. But quality—or lack of it—may have played a role, too. As the late president's son Robert opined when he saw the picture again in 1903, "it seemed to me that during those years he had kept tinkering at it until he had . . . nearly ruined it."[30]

By the time the painting was installed over the staircase leading to the U.S. Senate's public galleries, where it hangs today, Carpenter could at least content himself with the knowledge that the engraved adaptation had become one of the biggest best-sellers among all prints of the century. Perhaps its triumphant popularity was at least in part attributable to a subtle but major change that either Carpenter or Ritchie—or perhaps both—had made in the composition before it was mass-produced. In the original canvas, the Emancipation Proclamation itself rests on the cabinet table, and its author appears to have set it down to solicit advice from his ministers. But in the engraving, Lincoln clutches it firmly in his lap. A nearby inkwell holds a quill, which viewers may assume he will use to authorize the document. Now Lincoln was clearly its author, the promulgator of freedom, not the

curiously passive figure in the painting. As for the scene itself, it may still be the first reading of the proclamation, but it seems to hint at its ultimate adoption, too. These subtle alterations may have made an enormous difference in the print's public reception and enduring popularity.

By the time the engraving appeared, Lincoln's assassination had already catapulted him into the realm of national myth, making once controversial subjects associated with his presidency safe for popular consumption, and foolproof for profitable artistic commemoration. Where once his emancipation policy had aroused opposition that frightened away artists, now an anonymous poet presaged the introduction of a newly liberated Lincoln image by describing the martyr as "Our Moses he—whose faithful hand / Led us so near the promised land."[31]

Specific visual evidence arrived in prints that vivified this transfiguration, notably Currier and Ives's breakthrough 1865 lithograph of Lincoln raising a kneeling slave from bondage. The composition came straight out of "Am I Not a Man and a Brother" abolitionist iconography[32] (originally in the form of a ca. 1787 Wedgwood medallion)—unimaginable in mainstream emancipation imagery until Lincoln's death, and somewhat embarrassing to contemplate today. All but lost to today's generation is the fact that the kneeling slave had once been

a universally understood symbol of abolitionist yearn-
ing that inspired no less ardent an opponent of slavery
than Benjamin Franklin to predict that "it may have an
Effect equal to that of the best written Pamphlet in
procuring favour to those oppressed people."[33] What
seemed radical once and retrograde now, in 1865 increas-
ingly resurfaced in tributes to Lincoln portraying him
as a leader guided to emancipation by God. Currier and
Ives would consecrate its own influential resurrection of
the motif with an apt line from Leviticus: "Proclaim lib-
erty throughout all the land unto all the inhabitants
thereof."[34] Historian David Brion Davis has contended
that all such prints were "designed to emphasize the in-
debtedness and moral obligations of the emancipated
slaves as well as their dependence on the culture and
expectations of their liberators." But Davis does not
acknowledge the brew of mourning and mythification
that made such portrayals palatable in 1865, though
they had seemed too daring in 1863. Of course, these
Lincoln tributes also sold well because they made white
audiences feel noble about emancipation while express-
ing cautionary restraint about civil rights.[35]

The new marketplace vitality of the emancipation
genre was further demonstrated when the Carpenter-
Ritchie engraving spawned a number of post-1866 pirated
copies, brazenly churned out in an age when copyright
protection was unenforceable. One such unauthorized

"variant," by a fellow New Yorker named Edward Her-
line, attempted to mask its origins by changing the
seating order of the cabinet, whom Carpenter had
grouped according to political philosophy, with progres-
sives on the left and conservatives on the right. The re-
sult looked awkward, but as it was released in the frenzy
of emotion following Lincoln's death, few customers
likely noticed, much less objected. Yet another New
Yorker, Thomas Kelly, went even further, adding hero-
general Ulysses S. Grant to his own thinly disguised
Carpenter rip-off. Evidently also giddily regarding the
concurrent reopening of the long-obstructed Southern
marketplace, Kelly saw no reason not to issue a second
variant, this one substituting Confederate leaders for the
Lincoln cabinet, with Robert E. Lee in place of Grant. No
doubt few of its Lost Cause–oriented customers could
have imagined that Davis, of all people, was now unwit-
tingly clutching the Emancipation Proclamation!

The post-assassination onrush of Great Emancipator
prints suggested no large shift in public acceptance of the
rapidly changing role of African Americans in postwar
society, as few of the aforementioned 1865 or 1866 pictures
included people of color, either, unless in the pose of a
kneeling slave. But Lincoln's death had clearly liberated
printmakers from the marketplace doubts that had con-
strained production of such pictures while he lived. And
the demonstrated bravery of African American soldiers in

wartime had validated Lincoln's predictions and eased white fears of bloody insurrections. In this atmosphere, partisanship and racism were cast aside—at least in the graphic arts.

Thomas Nast, who in 1863 could barely imagine the impact of emancipation for the weekly pictorial press, now produced a striking illustration purporting to show Lincoln's welcome in the conquered Confederate capital, Richmond, where newly freed African Americans rushed to greet him in the streets.[36] Boston printmaker Benjamin B. Russell also vivified the moment—to be sure, interpreting it as yet another example of the kneeling-slave school of art—in a small print of surprisingly great power. In fact, liberated slaves had actually fallen on their knees upon Lincoln's arrival that day in Richmond, prompting him to declare: "Don't kneel to me, that is not right. You must kneel to God only, and thank him for the liberty you will hereafter enjoy."[37] Just days before his own death, Lincoln had provided artists a genuine "emancipation moment" at last.

Eventually, white printmakers also began tentatively supplying emancipation prints specifically targeted for another awakening and potentially profitable audience: African Americans themselves. As Frederick Douglass noted in 1870: "Heretofore, colored Americans have thought little of adorning their parlors with pictures. . . . Pictures come not with slavery and oppression and destitution, but with liberty, fair play, leisure, and refinement. These

conditions are now possible to colored American citizens, and I think the walls of their houses will soon begin to bear evidence of their altered relations to the people about them."[38] Picture publishers were never advocates or reformers; they were businessmen with an eye on sales. If long-neglected audiences might now evolve into print buyers—whether they were racist and defiant Southerners or free African Americans—the printmakers were delighted to provide them what they wanted.

Douglass's enthusiasm may have directly inspired the first emancipation prints designed specifically for this burgeoning market. In one example by an engraver known only as Richardson, the Good Book appeared from heaven to inspire Lincoln to proclaim freedom to a black church congregation celebrating both the revelation and the president alike. A truly extraordinary example of this genre came in 1896 with A. B. Daniel's *Emancipation Proclamation of President Lincoln,* which depicted an angel of color inspiring Lincoln, perhaps even handing the scroll of freedom to him. Lest prospective print buyers fail to understand how they were obligated to display the picture, it contained specific instructions—in verse:

Freedom! Oh, Freedom! Oh sweet welcome!
This joyful news was spoken by Lincoln.
Reverence him, though our skins are dark,
Reverence him in our churches and parks;

Let us teach our children to do the same,

And teach them never to forget his name.

He was our Moses, to us and our race,

And our children never should forget his face . . .

Judging by the fin-de-siècle appearance of this picture, it is clear that for several generations, the popularity of such images validated a prediction that one African American soldier had offered back in 1865: that Lincoln would "forever be cherished in our hearts."[39] Indeed, as Reconstruction-era schoolteacher Sarah Barnes remarked of the homes of the free African Americans she subsequently visited:

> I have often noticed in their cabins pictures of Abraham Lincoln sometimes when there was wanting the bare necessities of life, his face has appeared looking down from the black murky ceilings. I asked at one house, why this was so, and was answered: "He freed us, and I like him, so I have it there."[40]

In the final three decades of the century, basking in the transformative glow of martyrdom, Lincoln earned monumentality as well, as Northern cities clamored to outdo each other in tendering lucrative commissions for public sculpture of Lincoln as an emancipator. An unlikely teenage sculptress named Vinnie Ream, who regarded Lincoln as a personal challenge to her raw talent, helped fuel this

movement by securing sittings with the president late in his life. From awkward initial attempts she produced a brooding bust portrait, acclaim for which helped earn her a congressional commission to make a life-sized statue of Lincoln as emancipator for the U.S. Capitol, despite fierce opposition from the president's widow, who predicted: "Nothing but a mortifying failure, can be anticipated, which will be a severe trial to the nation & the world."[41]

Unveiled in January 1871 and widely copied by photographers, the full-figure marble showed Lincoln grasping the proclamation in one hand and extending his other in a classical heroic gesture meant to convey the benevolent granting of liberty. Though some critics of the day dismissed it ("a frightful abortion," said one), no less a judge than Lorado Taft declared it "an extraordinary work for a child and really a far more dignified product than many of its neighbors in the National Hall of Statuary."[42] Ream's statue has graced the Capitol Rotunda ever since, but not because its proponents outshouted its detractors. The sculpture was actually fated for removal at one point, but workers attempting to haul it away accidentally smashed the proclamation scroll. Mortified, they ordered repairs (sad to say, replacing it with a smaller one that lacked the writing incised on the original) and sheepishly left it where it had always stood.[43]

Ream's statue ratified the artistic decisions made earlier by painters Edward Marchant and Francis Carpenter: to eschew allegory and depict Lincoln as a scroll-toting

emancipator without attempting to interpret the impact of emancipation on slaves. When white artists and sculptors did attempt such calculations, they invariably showed slaves kneeling—or were they rising? It seldom seemed certain, and almost always seemed provocative. This ambivalence may have been designed to placate white audiences, but over time it offended black ones. Sculptor Randolph Rogers's 1866 model for *Lincoln and the Emancipated Slaves* was one of the earliest in the genre, completed so near in time to the publication of Currier and Ives's lithographic evocation of white benevolence that it is not impossible to imagine the print influencing the sculpture. However, when it was time for Rogers to fulfill a major commission from the Lincoln Monument Association of Philadelphia for a colossal bronze emancipator statue for Fairmount Park, he reverted to the image of Lincoln as author of freedom, grasping a quill in one hand and a scroll in the other. Even the uninspiring words of the proclamation itself appeared on one of the panels of its massive base.[44]

Yet the kneeling-slave genre did not disappear. It even attracted one accomplished black artist, David Bustill Bowser, who was equally capable of turning the image on its ear by painting a remarkably daring banner for a regiment of "colored" troops. The latter composition showed quite the opposite kind of scene: a black soldier, bayonet poised, killing a cowering Confederate.[45] Its

inscription echoed the motto of the state of Virginia, "Sic semper tyrannis," clearly identifying the Confederate defenders of slavery as the tyrants (and not the supposedly reluctant emancipator Lincoln, whose enemies routinely charged him with tyranny, too). This turned out to be a bitterly ironic choice, since Confederate sympathizer John Wilkes Booth later shouted these very words from the stage of Ford's Theatre on April 14, 1865, after fatally shooting Abraham Lincoln.[46] But when the banner was created, Bowser showed that even an artist of color was willing to move freely between seemingly incompatible genres, embracing both—no doubt for the right paid commission.

The kneeling-slave prototype was never more enduringly, if controversially, rendered than in Thomas Ball's emancipation group unveiled at Lincoln Park in Washington on the eleventh anniversary of the assassination, April 14, 1876. Commissioned and financed by donations from free people of color, its creation in one sense answered a plea from Frederick Douglass's neglected 1865 Lincoln eulogy: "Let the colored people of this country leave space for one stone" in memorializing Lincoln.[47] Ball intended his statue, as a surviving model suggests, to portray the slave as an ambiguous symbol, not quite a man, wearing a Phrygian liberty cap, the emblem of manumission, but appearing as only a docile beneficiary of Lincoln's beneficence. In its final,

monumental iteration, however, the freed slave became entirely human and markedly less subservient, straining his own rippling muscles to break the shackles that bind him.

One tradition holds that Ball modeled this portrait on photographs of one Archer Alexander, believed to have been the last slave freed in Missouri. But in an ironic twist, though few people of the day knew it, Alexander had risen no further in life in post-emancipation America than to become the servant of the man responsible for funding the Ball project, the founder of his state's Western Sanitary Commission. Even philanthropy knew its bounds. Ball himself distastefully implied that the original model had been a black man he hired in Florence, Italy, after the "horrible tidings" of the Lincoln assassination inspired him to create a tribute, but who was allowed to pose for at most three sessions because "he was not good enough to compensate for the unpleasantness of being obliged to conduct him through our apartment." In the end, the sculptor testified, he "decided to constitute myself both model and modeller," and finished his clay while posing half-naked on one knee before a pair of mirrors, so he "could not only see, but feel each muscle." Ball congratulated himself that he could have found no better model, "certainly, for the money." Thus the most famous kneeling slave in all emancipation iconography may be but a self-portrait of its creator.[48]

Understandably, modern audiences—and there is no evidence that there are many at Lincoln Park these days—are often repelled by the Ball group's depiction of the kneeling slave, however muscular, about to rise under Lincoln's outstretched hand. Moreover, in delivering the principal address at the unveiling, Douglass, who had admiringly called Lincoln "the black man's President" in 1865, now famously assessed him "preeminently the *white* man's president," conscious enough of the revisionism it signified by underlining the word in his manuscript. Historians have cited these electrifying words ever since as a major turning point in the decline of the Lincoln image among African Americans. Often overlooked is what else Douglass pointed out that day:

> In doing honor to the memory of our friend and liberator, we [do] the highest honor to ourselves and those who came after us . . . fastening ourselves to a name and fame imperishable and immortal.

As he argued:

> When it shall be said that the colored man is soulless . . . when the foul reproach of ingratitude is hurled at us, and it is attempted to scourge us beyond the range of human brotherhood, we may calmly point to the monument we have . . . erected to the memory of Abraham Lincoln.

To Douglass, crucially, the Ball monument, whatever the flaws of its artist or subject, marked "the first time that, in this form and manner, we have sought to do honor to an American great man." Let it endure, he proclaimed, "forever."[49]

When a Ball replica was unveiled in Boston three years later, as previously mentioned, Mayor Frederick Prince added a similar prediction: "No monument of granite or bronze is needed to perpetuate his memory, and hold his place in the affections of his countrymen." It would never be modified, he asserted, by the "corrosion of time," and would endure "as long as the human mind retains its capacity to know that liberty is the gift of Heaven to man, and that resistance to tyranny is obedience to God." As the words on the statue's plaque reiterated: "Amidst thy sacred effigies / Of old renown give place, / O city Freedom-loved; to his / Whose hand unchained a race."[50]

Notwithstanding such accolades, Lincoln's image as an emancipator eroded anyway, not only by the "corrosion of time" but also through a more nuanced artistic exploration of emancipation by twentieth-century black artists amidst a concurrent, growing consensus among contemporary white artists to emphasize Lincoln primarily as a generic healer and unifier. The Lincoln

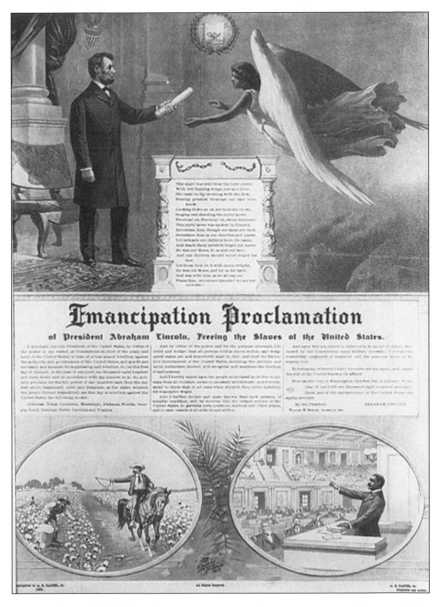

Designed specifically for African American audiences, A. B. Daniel's 1896 lithograph *Emancipation Proclamation / of President Abraham Lincoln, Freeing the Slaves of the United States* contained lines of verse instructing customers to purchase such tributes. (Author's collection)

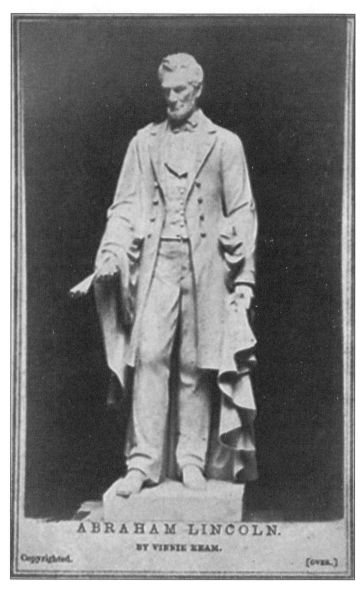

ABRAHAM LINCOLN.
BY VINNIE REAM.

Copyrighted. [OVER.]

This 1871 carte-de-visite photograph, *Abraham Lincoln / by Vinnie Ream,* depicted the controversial marble statue by the young sculptor (1847–1914) who had enjoyed life sittings with Lincoln while still a teenager. (Author's collection)

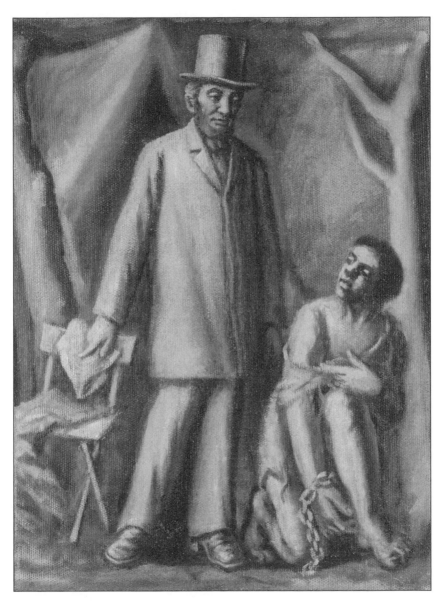

Though African American himself, artist David Bustill Bowser (1820–1900) was one of the first to depict Lincoln with a kneeling slave. This oil painting dates to the year of the proclamation, 1863. (Wadsworth Athenaeum Museum of Art / Art Resource, NY)

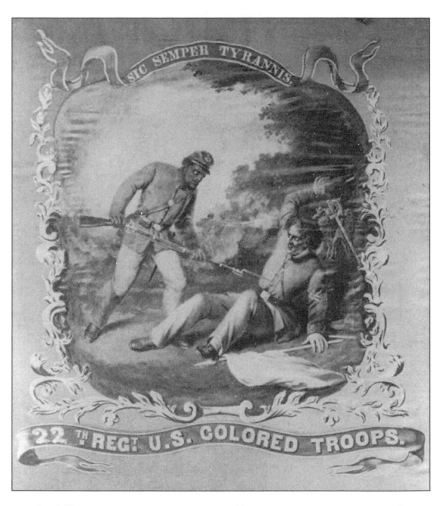

In a far different vein, Bowser's 1864 painted banner *Sic Semper Tyrannis / 22th Regt. U.S. Colored Troops* portrayed African Americans not as subservient to Lincoln, but as active warriors for their own freedom. Painted banner, 1864. (Library of Congress)

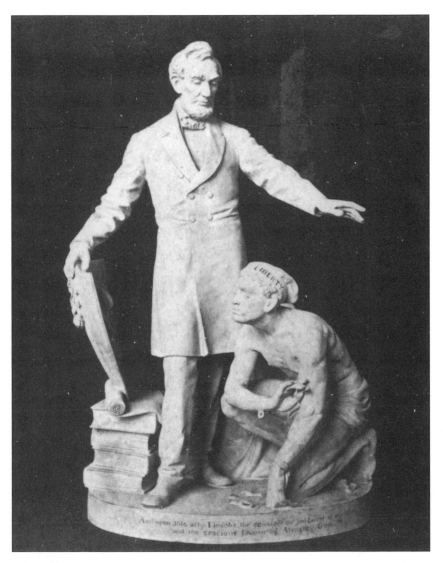

Thomas Ball's kneeling slave sculpture *Emancipation Group*, seen here as a clay model in an 1867 stereopticon photo by A. A. Childs and Co. of Boston, indicates that Ball (1819–1911) originally saw the slave figure only in symbolic terms—wearing a "liberty cap." (Author's collection)

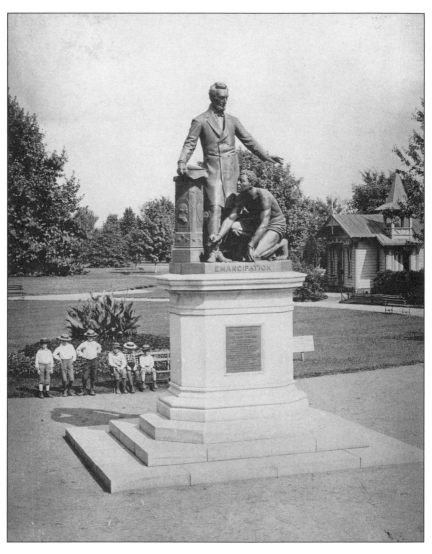

Once a major Washington tourist attraction, Ball's now politically incorrect 1871 statue makes most modern visitors uncomfortable. This photo was taken by J. F. Jarvis shortly after its unveiling in 1876. (Author's collection)

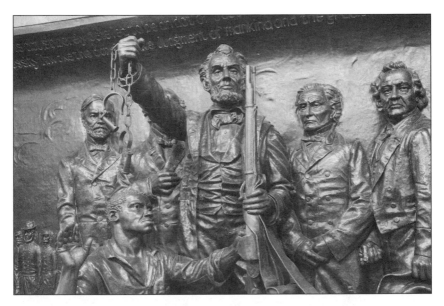

Built for the large Cuyahoga County Soldiers and Sailors monument in down-town Cleveland, Levi Scofield's (1842–1917) 1894 bronze relief, *Emancipation of the Slaves*, was remarkable for showing Lincoln handing a rifle to a "colored" soldier. (Photograph by the author)

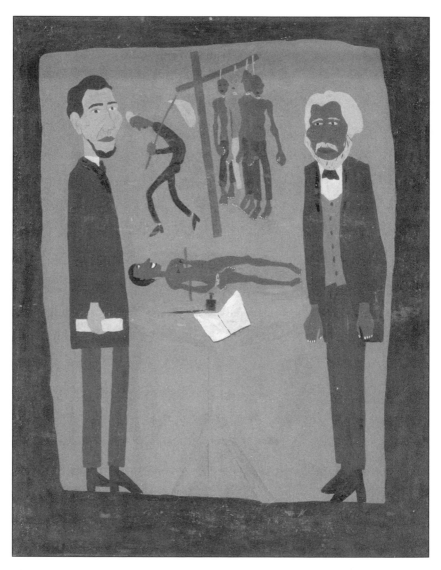

The ca. 1945 oil-on-paperboard painting *Let My People Free* by William H. Johnson (1901–1970) gave shared credit for black freedom to Lincoln and Frederick Douglass, and did not flinch from portraying the sacrifices of enslaved people themselves. (Smithsonian American Art Museum, Washington; Gift of the Harmon Foundation, 1967.59.649)

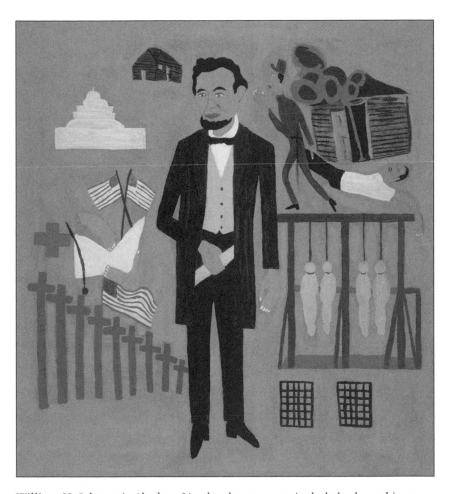

William H. Johnson's *Abraham Lincoln,* also ca. 1945, included a log cabin to remind viewers of Lincoln's humble origins, but acknowledged the martyrdom of dead soldiers and perhaps the victims of lynching. (Smithsonian American Art Museum, Washington; Gift of the Harmon Foundation, 1967.59.643)

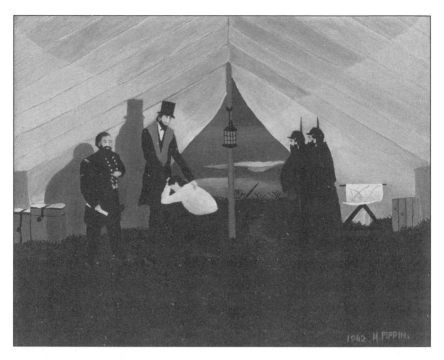

A unique variation on the theme of the kneeling slave, this 1942 painting by Horace Pippin (1888–1946) is called *Abe Lincoln, The Great Emancipator,* but here the beneficiary of freedom appears to be a pardoned white soldier. (Museum of Modern Art, New York; Gift of Helen Hawker Roelofs; Digital Image © The Museum of Modern Art / Licensed by SCALA / Art Resource, NY)

One of countless 2008 cartoons invoking—and humanizing—the Lincoln of the Lincoln Memorial to celebrate the election of Barack Obama, this cartoon by Steve Sack (b. 1953) appeared in the *Minneapolis Star Tribune*. (Reprinted with permission, Minneapolis Star Tribune)

Reputedly the best-selling *New Yorker* issue in the magazine's history, the November 17, 2008 edition featured this cover art by Bob Staake (b. 1957). (Staake / The New Yorker / Condé Nast Archive, Copyright © Condé Nast)

image endured, as David Blight has suggested, as "a collective statement of citizenship and identity."[51] But mainstream interpretations began presenting Lincoln as the quintessential American who rose inspiringly from poverty, rather than as the liberator of a race whose rights were now, inconveniently, subject to denial. A string of statues after 1900 more often depicted him as orator than liberator, with the opaque sentiments of the Gettysburg Address replacing the legal specifics of the Emancipation Proclamation. Perhaps the last gasp of nineteenth-century "emancipator" public statuary was the bold 1894 bronze by Levi Scofield for the Cleveland Union memorial, showing Lincoln handing not a scroll or a promise but a presumably loaded rifle to an emancipated slave—an artistic acknowledgment, at long last, that African Americans had fought directly for the freedom that Lincoln had promised. Even more remarkably, in sculptor Scofield's hands the graceful gesture of the liberator was replaced by a clenched fist and upraised arm. Here was a breathtaking precursor to the black power salute of a century later.

Yet old images died hard: a 1955 mural by Thomas Hart Benton, commissioned by a traditional black college, Lincoln University in Missouri, owed a clear debt to the seemingly indelible vision of the kneeling slave, although Benton's foreground imagery pointed to more

modern yearnings for good education. Smoke in the background was clearly meant to evoke gratitude for the sacrifices of Civil War soldiers, while Benton's Lincoln rose totem-like, not on a pedestal, but rather alongside a tree stump, as if perhaps to remind viewers that high political aspirations can arise from humble origins. Lincoln, after all, had cut such trees himself as a youth, and became in time his era's quintessential stump speaker as well.

It comes as little surprise that on the twentieth anniversary of the Emancipation Proclamation, Frederick Douglass had appraised Civil War memory as a still-unsettled "wilderness of thought and feeling." It took African American artists of the twentieth and twenty-first centuries to unscramble and reconstruct the image of emancipation, in a tumultuous era in which one black newspaper in Pittsburgh advised Depression-era readers "to turn Lincoln's picture to the Wall."[52]

Francis Carpenter's nineteenth-century concept of emancipation had brought eight benevolent white men around a table to decide the fate of black people. But African American artist William H. Johnson added Frederick Douglass to his startling reconception, *Let My People Free*. The table around which he and Lincoln meet holds not only a document awaiting signature but also the body of a murdered slave; it is not a podium but an altar, and these transformative leaders share equal

roles. Later, in a companion painting, Johnson boldly included among the emancipators John Brown, the radical martyr in whose memory—not Lincoln's—the refrain "Glory Glory Hallelujah" was after all first written. In his final composition in the series, Johnson's Lincoln clutches his emancipation document in that familiar Vinnie Ream–like manner. Now, however, the artist surrounds him not with glory but evidence of the horrors that preceded emancipation—and continued afterward.

Then there is the thought-provoking Horace Pippin work from 1942, *Abe Lincoln, The Great Emancipator,* with Lincoln rendered in so-called primitive style, about to uplift a grateful underling to liberty. But the kneeling figure here is white, not black, and the setting—a military tent—along with the accompanying uniformed figures, including General Grant himself, suggest that this is not an emancipation moment but a pardon moment, with Lincoln granting freedom to one of those sleeping sentries whose harsh punishments he often overturned. But perhaps, too, it reflected Romare Bearden's contention that it was "the white man who needs emancipation" now, as expiation for the sin of slavery.[53] Pippin took the kneeling slave and the by-then hackneyed title "Great Emancipator" and with ingenious originality reminded us of shared guilt and shared opportunity. As historian Steve Conn has put it, the painting not

only connected Lincoln "to the ideals of freedom" but "created a more universal figure, accessible to ordinary Americans."[54]

Inevitably, contemporary African American artists have brought further, and increasingly complex, insights to the genre. By the 1980s, a sympathetic Jean-Michel Basquiat was seeing Lincoln afresh as the one honest figure within a corrupt America for a composition he entitled *Obnoxious Liberals*. But it did not yet signal a full image revival, at least not in the view of the provocative contemporary artist Travis Somerville. His literally titled *Smokey Joe in My Mind* reveals a minstrel caricature frozen like a tattoo on the brow of a Lincoln rendered in blackface, provocatively questioning how many stereotypes had vanished, how many had endured, and how many had been conflated. And his *The New Land of Lincoln* from 2009 depicts a row of houses fronting a yard littered with a discarded, outsized bust of the sixteenth president. Lincoln's "house divided" seems at first glance symbolically reunited here through the connected urban dwellings, but Somerville may be suggesting that in this milieu marked by dashed hopes Lincoln has become irrelevant. The artist himself left only a clue when he explained: "I want the oppressed to be validated and the oppressors to be guilty. I [also] want people to realize that we are all connected in some way and we are responsible for each other."[55]

The acclaimed collage artist Kara Walker's *Emancipation Approximation*, a horrifying American version of the Greek myth of Leda and the Swan, showed its protagonist not merely disenfranchised but violated by a plantation owner, only to bear his children. Walker makes no direct statement about Lincoln here, emphasizing instead the strength of black women who had silently endured sexual violence in order to survive and proudly nurture the next generation. But her title left little doubt that she judged Lincoln's proclamation as a promise unfulfilled.

Few major white artists of the mid-twentieth century offered alternative or contradictory interpretations, though some, including Robert Rauschenberg, resurrected Lincoln in creations that stressed form, not meaning. Lincoln the emancipator had long before yielded to Lincoln the generic hero of national unity and triumphalism. The once central idea of Lincoln as liberator had been suppressed by whites who preferred to deemphasize goals from which their white contemporaries had retreated.[56]

So it had been when it came time to unveil the grandest Lincoln monument of all in 1922, Daniel Chester French's heroic statue for the new Lincoln Memorial in Washington. President Warren G. Harding argued in his dedicatory oration that Lincoln had ended slavery only to save the Union, not to bring

liberty to an oppressed people. He pointed with partic-
ular satisfaction to the site chosen for the memorial,
directly across the once-contested Potomac River from
Virginia—a symbol of sectional reconciliation that did
not bother to embrace racial reconciliation. No dissent
from this interpretation was heard from the other
white speakers that day, not even from Lincoln's sole
surviving son, Robert, who sat mutely for the entire
ceremony, eerily echoing the reticent silence with
which his father had signed the Emancipation Procla-
mation nearly three score years before. And as all the
dignitaries watched without objection, soldiers polic-
ing the Mall that day unceremoniously herded the
African Americans who gathered for the event into
the very back of the crowd. As historian Christopher
Thomas has noted, the event became "a microcosm
for the strained race relations of the day, marked by
the rhetoric of good intentions and the behavior of
bigotry."[57]

The colossal Lincoln statue dwelling inside the me-
morial clutches no emancipation scroll at all. Instead
he merely grips his throne-like chair, which is decorated
with the strapped pattern symbolizing power in classi-
cal art: a fasces, a device that would have proven an em-
barrassment had the modern Fascists already begun
their rise in distant Europe. Along the memorial's inte-

rior walls, the texts of what were intended to represent Lincoln's two greatest documents were carved directly on the walls: the Gettysburg Address and the Second Inaugural Address. True, each of these masterpieces had memorably addressed issues of slavery and freedom. But the original, defining words of the Emancipation Proclamation itself, once so dominant in American iconography, were now nowhere to be seen.

The only black orator at that 1922 opening ceremony, one who hoped to address a notion that Lincoln himself had first proposed at Gettysburg, America's "unfinished work," was Robert Russa Moton. As Booker T. Washington's successor as director of the Tuskegee Institute, Moton was patronizingly invited to the event to "speak for his race." But he was also required to submit his draft oration in advance, and after reviewing it, the organizing committee let Moton know he would not be permitted to say a portion of what he had written: it seemed too inflammatory, too critical of America. What Moton hoped to include that day was:

> So long as any group is denied the fullest privilege of a citizen to share both the making and the execution of the law which shapes its destiny—so long as any group does not enjoy every right and every privilege that belongs to every American citizen without regard to race, creed or color,

the task for which the immortal Lincoln gave the last full measure of devotion—that task is still unfinished.[58]

Although those thoughts remained unexpressed, Moton lived just long enough to see Marian Anderson use the Lincoln Memorial as the backdrop for her watershed 1939 concert. "In one bold stroke," Scott Sandage contended, "the Easter concert swept away the shrine's official dedication to the 'savior of the union' and made it a stronghold of racial justice."[59] But Sandage missed the equally valid point that widely seen newsreel footage of the African American opera star singing before the iconic sculpture had suggested once again—since a picture was still worth a thousand words, even when those words were set to music—that Lincoln remained a relevant part of any discussion of breaking further barriers to equality. Romare Bearden may have said it best, albeit most colloquially, when he acknowledged that Lincoln remained as much "a part of the actuality of the Afro-American experience, as were the domino games and the hoe cakes for Sunday morning breakfast."[60]

Twenty-four years after Marian Anderson and a full century after emancipation, Martin Luther King Jr. stood before the memorial to praise Lincoln and the proclamation, even while demanding that America of the 1960s live up at last to the unfulfilled promises of the 1860s. Through the pervasive medium of televi-

sion, Lincoln again became a visual touchstone for freedom as millions watched the event from their homes.

The memorial emerged yet again as a potent symbol when President-elect Obama hosted a gala on its steps just hours before taking the oath of office in 2009 (using the same Bible Lincoln had used in 1861). As if in response, the nation's graphic artists, heirs to the traditions of caricature once employed against Lincoln and his proclamation, cheered the arrival of the nation's first African American president in an outpouring of cartoon art that emphasized connections between America's past and future. Now an animated Lincoln Memorial statue could be seen offering Obama a thumbs-up or a fist bump, or joining the phone-camera generation to capture this history-making moment just like everyone else. The technology would have been for Lincoln unrecognizable. But the yearning for visual records of history-altering drama was unchanged from his own time. Rescued from neglect and controversy by Barack Obama's ascension and admiration, here was Lincoln come full circle: from memory to monument back to memory, and finally a witness to the task he had not lived to complete.

The story ended—at least for now—when President Obama ushered those civil rights veterans on a tour of his office in 2010 to view the document once celebrated

so joyfully as America's second declaration of indepen-
dence. It is odd but undeniably true that President
Obama's modest photo opportunity that January morn-
ing produced pictures that were infinitely more widely
seen than the original Emancipation Proclamation sign-
ing ceremony itself and its aftermath—a virtual torrent
of images on Facebook, Twitter, and the White House
website that endure on the new national canvas, the
World Wide Web—perhaps representing the ultimate tri-
umph of medium over message. Even in Barack Obama's
embrace, the image of Lincoln remains more generic than
specific, more about vague notions of leadership and good
government than about the watershed moment of
emancipation. When, even more recently, the president
sought to provide a photo opportunity to celebrate the
last-minute avoidance of a government shutdown in
March 2011, he was seen galloping up the steps of the
Lincoln Memorial to greet startled tourists and empha-
size the fact that the statue remained open to visitors—
regardless of precisely what that statue signified or did
not signify either in 1922 or 2011. That these images, large
and small, personal and public alike, retain the power to
engage, enchant, and provoke, so many years later,
confirms what A. Philip Randolph said of the power
of imagery at the dawn of the civil rights movement in
1958. Any "human cause," he declared, "though great

and imperative, must be given sharp picturization. The propaganda of the deed is more powerful than the propaganda of the word."[61]

Although Lincoln remains among the most widely portrayed Americans in our history, his image persists in paradox, as poet Langston Hughes sensed when he saw the Lincoln Memorial in 1926. Here he encountered an irresistible father figure, heroic yet remote, welcoming yet inscrutable. Here was the man who had performed the deed, had not been immune from the propaganda it stimulated, but above all remained worthy of attention and artistic inquiry. Hughes's words might usefully be considered afresh by a new generation for whom the most relevant example of Lincoln iconography may be the now famous illustration that graced the cover of the *New Yorker* to commemorate the Obama inauguration.

As Hughes wrote of the marble man residing inside the sanctuary that the *New Yorker* inventively reimagined in 2009, surmounting it with a halo-like Obama *O* as a subtle visual acknowledgment of the continuum of American history:

> Let's go see old Abe,
> Sitting in the marble and the moonlight,
> Sitting lonely in the marble and the moonlight,

Quiet for ten thousand centuries, old Abe.
Quiet for a million, million years.

Quiet—

And yet a voice forever
Against the
Timeless walls
Of time—
Old Abe.

NOTES

ACKNOWLEDGMENTS

INDEX

Notes

INTRODUCTION

1. Speech to the Baltimore Sanitary Fair, April 18, 1864, in *The Collected Works of Abraham Lincoln*, ed. Roy P. Basler (New Brunswick, NJ: Rutgers University Press, 1953-1955), 7:301.
2. Quoting the Gettysburg Address, November 19, 1863, ibid., 23.

I. THE BOW OF PROMISE

1. "Fred. Douglass on President Lincoln," *New York Times*, June 2, 1865, and manuscript of the eulogy, Frederick Douglass Papers, Library of Congress, Reel 19; *Frederick Douglass: Selected Speeches and Writings*, ed. Philip S. Foner and Yuval Taylor (Chicago: Lawrence Hill Books, 1975), 618.
2. William Safire, *Freedom* (Garden City, NY: Doubleday, 1987).
3. Ibid., 1071.
4. John Stauffer, *Giants: The Parallel Lives of Frederick Douglass and Abraham Lincoln* (New York: Twelve, 2008), 268.
5. Lincoln's temperance address on Washington's 110th birthday, February 22, 1842, in *The Collected Works of Abraham Lincoln*, ed. Roy P. Basler (hereinafter referred to as *Collected Works*) (New Brunswick, NJ: Rutgers University Press, 1953-1955), 1:279; farewell address to Springfield, February 11, 1861, 4:191.

6. Ibid., 5:111, 136.
7. *New York Times,* March 7, 1862; Lincoln to Henry J. Raymond, March 9, 1862, *Collected Works,* 5:153.
8. *Collected Works,* 5:318-19.
9. "Stormy meeting" reported in Allen C. Guelzo, *Lincoln's Emancipation Proclamation* (New York: Simon and Schuster, 2005), 109.
10. See Earl Schenk Miers, ed., *Lincoln Day by Day: A Chronology, 1809-1865* (Washington, DC: Lincoln Sesquicentennial Commission, 1960), vol. 3.
11. Charles Eugene Hamlin, *The Life and Times of Hannibal Hamlin* (Cambridge, MA: Riverside Press, 1899), 2:428-29.
12. "Senator Hamlin, of Maine. His Cozy Home in Maine— Desire to Retire from Public Life," *Boston Herald,* reprinted in *New York Times,* September 8, 1879.
13. Hamlin, *Life and Times,* 2:429; *Congressional Globe,* 37th Congress, 2nd Session, June 19, 1862, 2798; Hannibal Hamlin to Lincoln, September 25, 1862, Abraham Lincoln Papers, Library of Congress (hereinafter referred to as LPLC).
14. "Senator Hamlin, of Maine."
15. *Memoirs and Letters of Charles Sumner,* ed. E. L. Pierce (Boston: Roberts Brothers, 1894), 4:185.
16. McClellan to Lincoln, July 7, 1862, and to Mary Ellen McClellan, July 10, 1862, in *The Civil War Papers of George B. McClellan: Selected Correspondence, 1860-1865,* ed. Stephen W. Sears (New York: Ticknor and Fields, 1989), 344-45, 348.
17. *New York Herald,* July 11, 1862.
18. James R. Gilmore, *Personal Recollections of Abraham Lincoln and the Civil War* (Boston: L. C. Page, 1898), 75-76.
19. Gideon Welles, *Diary* (Boston: Houghton Mifflin, 1911), 1:70-71.
20. Ralph Korngold, *Thaddeus Stevens: A Being Darkly Wise and Rudely Great* (New York: Harcourt Brace, 1955), 180; Anna Ella Carroll to Lincoln, July 14, 1862, LPLC.

21. Quoted in Larry Tagg, *The Unpopular Mr. Lincoln: The Story of America's Most Unpopular President* (El Dorado Hills, CA: Savas Beatie Press, 1009), 277.

22. *The Diary of Orville Hickman Browning*, ed. Theodore Calvin Pease and James G. Randall (Springfield, IL: Illinois State Historical Library, 1925), 1:557-58.

23. Mark E. Neely Jr., *The Abraham Lincoln Encyclopedia* (New York: McGraw-Hill, 1982), 39; Browning, *Diary*, 1:607.

24. *Collected Works*, 5:328-31.

25. John Hay to Mary Jay (daughter of John Jay), July 20, 1862, in *At Lincoln's Side: John Hay's Civil War Correspondence and Selected Writings*, ed. Michael Burlingame (Carbondale: Southern Illinois University Press, 2000), 23.

26. Lincoln later entitled this draft "Emancipation Proclamation as first sketched and shown to the Cabinet in July 1862." See *Collected Works*, 5:336-37.

27. F[rancis]. B. Carpenter, *Six Months at the White House with Abraham Lincoln: The Story of a Picture* (New York: Hurd and Houghton, 1867), 21.

28. Ibid.

29. *The Salmon P. Chase Papers*, ed. John Niven (Kent, OH: Kent State University Press, 1993), 1:351.

30. Carpenter, *Six Months at the White House*, 22.

31. Ibid.

32. Lincoln to Reverdy Johnson, July 26, 1862, to Cuthbert Bullitt, July 28, 1862, *Collected Works*, 5:343, 346.

33. John G. Nicolay and John Hay, *Abraham Lincoln: A History* (New York: Century, 1890), 6:148-49.

34. For a modern reinterpretation of the meeting, the delegation, and their status, see Kate Masur, "The African American Delegation to Abraham Lincoln: a Reappraisal," *Civil War History* 56 (June 2010): 117-44, esp. 131; *Collected Works*, 5:372.

35. *Collected Works*, 5:373-75.

36. E. M. Thomas to Lincoln, August 16, 1862, LPLC.

37. *Christian Recorder,* September 27, 1862, quoted in Henry Louis Gates Jr., *Lincoln on Race and Slavery* (Princeton, NJ: Princeton University Press, 2009), 236.

38. Eric Foner, *The Fiery Trial: Abraham Lincoln and American Slavery* (New York: W. W. Norton, 2010), 225–26.

39. Frederick Douglass, "The Slaveholders' Rebellion," speech at Himrods Corner, New York, July 4, 1862, and "The President and His Speeches," *Douglass' Monthly,* September 1862, in *Frederick Douglass: Selected Speeches and Writings,* 506, 511–13.

40. Orville H. Browning to Lincoln, August 11, 1862, LPLC.

41. Chase, *Diary,* August 15, 1862.

42. Eric Foner, "Lincoln and Colonization," in John Milton Cooper and Thomas J. Knock, eds., *Jefferson, Lincoln, and Wilson: The American Dilemma of Race and Democracy* (Charlottesville: University of Virginia Press, 2010), 120.

43. Lincoln to Isaac N. Arnold and Owen Lovejoy at the Soldiers' Home, July 18, 1862, in Arnold, *The History of Abraham Lincoln, and the Overthrow of Slavery* (Chicago: Clarke, 1867), 288. This long book, a rather muddled account that confused Lincoln's message about compensated emancipation with his annual message to Congress five months later, argued that congressional leaders such as the author and Owen Lovejoy, representing "public sentiment in the North," pushed Lincoln to emancipation.

44. "Prayer of Twenty Millions," *New York Tribune,* August 20, 1862.

45. Lincoln to Horace Greeley, August 22, 1862, *Collected Works,* 5:388–89.

46. James C. Welling, *Reminiscences of Abraham Lincoln by Distinguished Men of His Time,* ed. Allen Thorndike Rice. (New York: North American Publishing, 1886), 523, 540.

Welling reflected the administration's view by assailing Greeley's editorial for its "truculence." Ibid., 523.

47. *New York Journal of Commerce,* August 27, 1862; Thurlow Weed to Lincoln, August 24, 1862, LPLC.

48. *Greeley on Lincoln . . . ,* ed. Joel Benton (New York: Baker and Taylor, 1893), 62.

49. "Lincoln. Personal Reminiscences of Him by James R. Gilmore," *New York Times,* October 8, 1898.

50. Gilmore, *Personal Recollections of Abraham Lincoln,* 81–83.

51. Whitelaw Reid, "Lincoln and Greeley," in *A Radical View: The "Agate" Dispatches of Whitelaw Reid, 1861–1865* (Memphis, TN: Memphis State University Press, 1976), 1:215; *Greeley on Lincoln,* 63; Gilmore, *Personal Recollections of Abraham Lincoln and the Civil War,* 84.

52. *Greeley on Lincoln,* 63.

53. *New York Tribune,* August 22, 1862; *New York Times,* August 24 and 25, 1862.

54. Greeley quoted in Stefan Lorant, *Lincoln: A Picture Story of His Life,* rev. ed. (New York: W. W. Norton, 1969), 159.

55. *New York Times,* August 26, 1862.

56. Adam Gurowski, *Diary* (Boston: Lee and Shepard, 1862), 245.

57. *Chicago Tribune,* August 8, 1862, August 27, 1862 (reprinted in Foner, *The Fiery Trial,* 230); Washington *Evening Star,* August 4, 1862.

58. *New York Times,* August 26, 1862; *New York Evening Post,* September 23, 1862; *New York World,* August 18, 1862.

59. Isaac N. Arnold, *Sketch of the Life of Abraham Lincoln . . .* (New York: John B. Bachelder, 1869), 34.

60. *Mary Chesnut's Civil War,* ed. C. Vann Woodward (New Haven, CT: Yale University Press, 1981), 407. Her July entry may well have been inspired by the prospect of compensated emancipation in the border states, but it certainly

advanced the expectation that a blow of some kind against Southern slavery was in prospect.

61. *Philadelphia Press,* July 30, 1862, reprinted in Elwyn Burns Robinson, "The *Press:* President Lincoln's Philadelphia Organ," *Pennsylvania Magazine of History and Biography* 65 (1941): 169.

62. Quoted in Guelzo, *Lincoln's Emancipation Proclamation,* 123.

63. Joshua Speed to Lincoln, September 17, 1862, LPLC.

64. James Speed to Lincoln, July 28, 1862, LPLC.

65. Clay quoted in *Recollected Words of Abraham Lincoln,* ed. Don E. Fehrenbacher and Virginia Fehrenbacher (Stanford, CA: Stanford University Press, 1996), 107-8.

66. Sumner to John A. Andrew, May 28, 1862, *Memoirs and Letters of Charles Sumner,* 2:115; Guelzo, *Lincoln's Emancipation Proclamation,* 126; *Memoirs and Letters of Charles Sumner,* 4:65.

67. James A. Hamilton to E. D. Morgan, August 4, 1862, in Hamilton, *Reminiscences of James A. Hamilton; or, Men and Events, at Home and Abroad, During Three Quarters of a Century* (New York: Charles Scribner, 1869), 526.

68. Wendell Phillips to the editor of the *New York Tribune,* August 20, 1862, and speech at Abingdon Grove, August 1, 1862, in Wendell Phillips, *Speeches, Lectures, and Letters* (Boston: Walker, Wise, 1864), 465, 462; Phillips to Gay, September 2, 1862, Gay Papers, Library of Congress, Sydney Howard Gay Papers, Columbia University.

69. Adams Hill to S. H. Gay, August 1862, Gay Papers, Columbia University, and Allan Nevins, *The War for the Union: War Becomes Revolution, 1862–1863* (New York: Charles Scribner's Sons, 1960) 233n42.

70. Robert Dale Owen to Edwin M. Stanton, July 23, 1862, LPLC. A few days later, Lincoln appropriated Owen's language to tell Cuthbert Bullitt, "What I deal with is too vast for malicious dealing" (*Collected Works,* 5:346). Owen

wrote directly to Lincoln on September 17, advising:
"Property in man, always morally unjust, has become
nationally dangerous. Property that endangers the safety of
a nation should not be suffered to remain in the hands of
its citizens." Owen attached his own draft of a presidential
proclamation of emancipation.

71. Conversation with Leonard Swett [and John G. Nicolay],
March 14, 1878, in Nicolay, *An Oral History of Abraham
Lincoln: John G. Nicolay's Interviews and Essays,* ed. Michael
Burlingame (Carbondale: Southern Illinois University
Press, 1996), 58–59. One Illinoisan who was not taken into
the president's confidence, Senator Lyman Trumbull, later
jealously told Lincoln biographer Jesse Weik that he and
coauthor William Herndon had succumbed to the "old
notion that Lincoln had opened the way for freeing of
slaves whereas Congress had really done it by two laws
passed long before the Emancipation Proclamation was
issued." Ibid., 148–49n69.

72. Edward McPherson, *The Political History of the United States
of America During the Great Rebellion, from November 6, 1860,
to July 4, 1864* . . . (Washington, DC: Philip and Solomons,
1864), 233; Gideon Welles, *Lincoln's Administration,* ed. Albert
Mordell (New York: Twayne, 1960), originally published as
essays by Welles in the *Atlantic Monthly* in 1876 and 1878;
Guelzo, *Lincoln's Emancipation Proclamation,* 129.

73. Hiram Barney to Gideon Welles, September 27, 1877, Welles
Papers, New York Public Library, reported in Guelzo, *Lincoln's
Emancipation Proclamation,* 131. See also Henry Wilson and
Samuel Hunt, *History of the Rise and Fall of the Slave Power in
America* (Boston: Houghton, Mifflin, 1877), 3:388.

74. *Lincoln's Journalist: John Hay's Anonymous Writings for the
Press, 1860–1864,* ed. Michael Burlingame (Carbondale:
Southern Illinois University Press, 1998), 307–11.

75. William W. Patton, *President Lincoln and the Chicago Memorial on Emancipation,* paper read to the Maryland Historical Society, December 12, 1887 (Baltimore: Maryland Historical Society, 1888), 13.

76. *Collected Works,* 419-21.

77. Chase, *Diary,* 189; *The Diary of George Templeton Strong,* ed. Allan Nevins and Milton Halsey Thomas (New York: Macmillan, 1952), 2:256.

78. Mark E. Neely Jr., "Colonization and the Myth That Lincoln Prepared the People for Emancipation," in William A. Blair and Karen Fisher Younger, eds., *Lincoln's Proclamation: Emancipation Reconsidered* (Chapel Hill: University of North Carolina Press, 2009), 69.

79. *Collected Works,* 5:423-24.

80. For a cogent argument, see Adam I. P. Smith, *No Party Now: Politics in the Civil War North* (New York: Oxford University Press, 2006), 56.

81. *New York Evening Post,* September 15, 1862.

82. [Charles Farrar Browne], *Artemus Ward: His Book, Or the Confessions and Experiences of a Showman* (London: Ward, Lock, and Tyler, 1866 [1865]), 15.

83. Welles, *Diary,* 1:143. For a riveting account of the historic cabinet meeting, see John Hope Franklin, *The Emancipation Proclamation* (Wheeling, IL: Harlan Davidson, 1995 [1963]), 42-45.

84. Patton, *President Lincoln and the Chicago Memorial,* 35-36.

85. A survey of period press response suggests that the most conservative and race-conscious Democratic journals, predictably, opposed the proclamation, as did many European newspapers. Conservative Republican papers, however, joined abolitionist-minded publications by lavishing praise on it and its author. For examples, see Herbert Mitgang, ed., *Lincoln as They Saw Him* (New York: Rinehart, 1956), esp. 301-33.

86. Carpenter, *Six Months at the White House*, 77.
87. Horace Greeley, "Greeley's Estimate of Lincoln: An Unpublished Address . . .", originally written 1868, *The Century Illustrated Monthly Magazine* 42 (October 1891): 380.
88. Fragment, ca. December 31, 1860, *Collected Works* 4:168-69.
89. *Douglass' Monthly*, October 1862, in *Frederick Douglass, Selected Speeches and Writings*, 518, 520.
90. *Pacific Appeal*, October 4, 1862, quoted in Foner, *The Fiery Trial*, 245.
91. *New York Times*, November 27, 1863. See Harold Holzer, *Washington and Lincoln Portrayed: National Icons in Popular Prints* (Jefferson, NC: McFarland Books, 1993), 188.

2. EMANCIPATOR VERSUS PETTIFOGGER

1. J. Robert Mendte, *The Union League of Philadelphia Celebrates 125 Years, 1862–1987* (Devon, PA: William T. Cooke, 1987), 10.
2. Charles G. Leland to John G. Nicolay, April 1863, John G. Nicolay Papers, Library of Congress.
3. Stewart Farrar, prologue to Charles G. Leland, *Arcadia, or the Gospel of the Witches* (Blaine, WA: Phoenix Publishing, 1998 [1899]), 14.
4. George H. Boker to John G. Nicolay, June 1, 1864, John G. Nicolay Papers, Library of Congress.
5. *The Collected Works of Abraham Lincoln*, ed. Roy P. Basler (hereinafter cited as *Collected Works*) (New Brunswick, NJ: Rutgers University Press, 1953-1955), 6:533-34.
6. Ibid., 7:397.
7. *Philadelphia Inquirer*, reprinted in *The Sanitary Commission Bulletin* 1 (June 16, 1864): 494; Charles Eberstadt, *Lincoln's Emancipation Proclamation* (New York: Duschnes Crawford, 1950), 38.
8. See, for example, Harold Holzer, Mark E. Neely Jr., and Gabor S. Boritt, *The Lincoln Image: Abraham Lincoln and the Popular Print* (New York: Charles Scribner's Sons, 1984), esp. 1-78;

and Mark E. Neely Jr. and Harold Holzer, *The Union Image: Popular Prints of the Civil War North* (Chapel Hill: University of North Carolina Press, 2000), esp. 129–60.

9. The so-called Leland-Boker autographed broadside edition of the Emancipation Proclamation was published in June 1864 by Charles G. Leland and George H. Boker; each was signed by Lincoln, Secretary of State William H. Seward, and Lincoln's personal secretary, John G. Nicolay. For the full history of this edition, see Eberstadt, *Lincoln's Emancipation Proclamation,* 37–39.

10. Nancy Benac, "Emancipation Proclamation to Exit Oval Office Perch," Associated Press, June 29, 2010.

11. See, for example, *Illinois Daily State Journal* (Lincoln's pro-Republican hometown newspaper), quoted in Herbert Mitgang, ed., *Lincoln as They Saw Him* (New York: Rinehart, 1956), 306.

12. Quoted in Francis B. Carpenter, *Six Months at the White House: The Story of a Picture* (New York: Hurd and Houghton, 1867), 77–78.

13. Abraham Lincoln, *Lincoln on Race and Slavery,* ed. Henry Louis Gates Jr. (Princeton, NJ: Princeton University Press, 2009), 53.

14. Carpenter, *Six Months at the White House,* 269.

15. For the final text, see *Collected Works,* 6:29–30.

16. *Douglass' Monthly,* February 1863.

17. Richard Hofstadter, *The American Political Tradition and the Men Who Made It* (New York: Alfred A. Knopf, 1973 [1948]), 129.

18. Quoted in Ralph Korngold, *Thaddeus Stevens: A Being Darkly Wise and Rudely Great* (New York: Harcourt Brace, 1955), 180.

19. Karl Marx, "On Events in North America," *Die Presse* [Vienna, Austria], October 12, 1862, translated and reprinted in Saul K. Padover, *Karl Marx on America and the*

Civil War (New York: McGraw-Hill, 1972), 221-22; "historic content" quoted in Mark E. Neely Jr., *The Abraham Lincoln Encyclopedia* (New York: McGraw-Hill, 1982), 104.

20. Benjamin Quarles, *Lincoln and the Negro* (New York: Oxford University Press, 1962), 149.

21. James G. Randall, *Lincoln and the South* (Baton Rouge: Louisiana State University Press, 1946), 82, 97, 108.

22. Lerone Bennett Jr., *Forced into Glory: Abraham Lincoln's White Dream* (Chicago: Johnson, 2000), 245, 533, 536; George M. Fredrickson, *Big Enough to be Inconsistent: Abraham Lincoln Confronts Slavery and Race* (Cambridge, MA: Harvard University Press, 2008), 16.

23. Handwritten manuscript of June 1865, Library of Congress; *Frederick Douglass: Selected Speeches and Writings,* ed. Philip S. Foner and Yuval Taylor (Chicago: Lawrence Hill Books, 1999), 560.

24. "Black man's President" quote is from manuscript of Douglass's speech at Cooper Union, June 1865; paraphrased in "Fred. Douglass on President Lincoln. Vast Gathering at the Cooper Institute. The Speaker's Views on the Future of His Race," *New York Times,* June 1, 1865. "White man's president" is from his oration at the dedication of the Freedmen's Monument, Washington, April 14, 1876, in *Frederick Douglass: Selected Speeches and Writings,* 618.

25. Thomas Eckert, quoted in David Homer Bates, *Lincoln in the Telegraph Office* (New York: Century, 1907), 138-41.

26. William O. Stoddard, *Lincoln's White House Secretary: The Adventurous Life of William O. Stoddard,* ed. Harold Holzer (Carbondale, IL: Southern Illinois University Press, 207), 291.

27. William Lloyd Garrison to Fanny Garrison, in *Let the Oppressed Go Free,* vol. 5 of *The Letters of William Lloyd Garrison,* ed. Walter M. Merrill (Cambridge, MA: Harvard University Press, 1979), 114.

28. Allan Nevins, *The War for the Union: War Becomes Revolution, 1862–1863* (New York: Charles Scribner's Sons, 1960), 234.

29. George William Curtis to Frederick Law Olmsted (head of the U.S. Sanitary Commission), September 29, 1862, in Nevins, *War for the Union*, 237.

30. Adam Gurowski, *Diary, from March 4, 1861, to November 12, 1862* (Boston: Lee and Shepard, 1862), 278.

31. Porter to Manton Marble, quoted in Nevins, *The War for the Union: War Becomes Revolution*, 238; George B. McClellan to Mary Ellen McClellan, September 15, 1862, in *The Civil War Papers of George B. McClellan: Selected Correspondence, 1860–1865,* ed. Stephen W. Sears (New York: Ticknor and Fields, 1989), 481. Lincoln was probably not surprised by McClellan's hostile reaction. On July 7 McClellan had handed the president a peremptory letter during one of his visits to the army in the field, offering the uninvited advice: "Military power should not be allowed to interfere with the relations of servitude, either by supporting or impairing the authority of the master" (ibid., 345).

32. *Collected Works*, 5:438.

33. London *Times,* October 7, 1862, reprinted in Mitgang, *Lincoln as They Saw Him,* 319–22.

34. Lincoln to Hannibal Hamlin, September 28, 1862, *Collected Works,* 5:444.

35. For details of the devastating 1862 election, see Allen C. Guelzo, *Lincoln's Emancipation Proclamation* (New York: Simon and Schuster, 2005), 167. *Valley Spirit,* quoted in Edward L. Ayers, *In the Presence of Mine Enemies: The Civil War in the Heart of America* (New York; W. W. Norton, 2003).

36. *Collected Works*, 5:433–36.

37. *Chicago Tribune,* May 24, 1862.

38. Ibid., September 23, 1862.

39. *Frederick Douglass: Selected Speeches and Writings,* 517.

40. W. B. Lowry, H. Catlin, and J. F. Dowling to Lincoln, September 23, 1862, in Lincoln Papers, Library of Congress (hereinafter referred to as LPLC).

41. Ralph Waldo Emerson, "The President's Proclamation," *Atlantic Monthly* 10 (November 1862): 638-39.

42. L. A. Whitely to James Gordon Bennett, September 24, 1862, quoted in J. Cutler Andrews, *The North Reports the Civil War* (Pittsburgh: University of Pittsburgh Press, 1955), 316.

43. George Livermore to Charles Sumner, December 25, 1862, LPLC. Livermore died in August 1864, and Sumner published a tribute to his friend in the *Boston Advertiser*. See *Memoir and Letters of Charles Sumner*, ed. Edward L. Pierce (Boston: Roberts Brothers, 1894), 4:261. For Livermore's treatise, see George Livermore, *An Historical Research Respecting the Opinions of the Founders of the Republic on Negroes as Slaves, as Citizens, and as Soldiers* ... (Boston: A. Williams, 1862).

44. The pen was known in its day as the Washington model. See Benson J. Lossing, *Pictorial History of the Civil War in the United States of America* (Hartford, CT: Thomas Belknap, 1874), 2:564n1.

45. Livermore to Sumner, January 5, 1863, LPLC.

46. Schuyler Colfax to Lincoln, December 31, 1862, LPLC.

47. Lincoln's secretary, John Nicolay, wired the editors of both the *New York Times* and *New York Tribune* on New Year's Eve that "the Proclamation cannot be telegraphed to you until during the day tomorrow." See *With Lincoln at the White House: Letters, Memoranda, and Other Writings of John G. Nicolay, 1860–1865*, ed. Michael Burlingame (Carbondale: Southern Illinois University Press, 2000), 98.

48. *The Diary of George Templeton Strong*, ed. Allan Nevins and Milton Halsey Thomas (New York: Macmillan, 1952), 3:284.

49. Remarks to pro-Union Kentuckians at the White House, November 21, 1862, *Collected Works,* 5:503.

50. Quoted in James C. Welling, "The Emancipation Proclamation," *North American Review* 130 (February 1880): 172.

51. John D. Defrees to John G. Nicolay, December 17, 1862, Nicolay Papers, Library of Congress.

52. See Harold Holzer, ed., *The Lincoln Anthology: Great Writers on His Life and Legacy from 1860 to Now* (New York: Library of America, 2009), 443.

53. Phillip Shaw Paludan, "Lincoln and Negro Slavery: I Haven't Got Time for the Pain," *Journal of the Abraham Lincoln Association* 27 (Summer 2006): 21.

54. For an excellent discussion of Lincoln's quest for a "coherent legal and constitutional theory to justify emancipation," see Paul Finkelman, "Lincoln, Emancipation, and the Limits of Constitutional Change," *Supreme Court Review,* 2008, 360.

55. Mark E. Neely Jr., *The Last Best Hope of Earth: Abraham Lincoln and the Promise of America* (Cambridge, MA: Harvard University Press, 1993), 113.

56. This point was forcefully made by historian William W. Freehling, who refuted Hofstadter and described the proclamation as "a relentless deployment of military power." See Freehling, *The South vs. the South: How Anti-Confederate Southerners Shapes the Course of the Civil War* (New York: Oxford University Press, 1991), 117–18.

57. Lincoln to Charles D. Robinson (a Democratic editor in Green Bay, Wisconsin), August 17, 1862, *Collected Works,* 7:500.

58. *New York Tribune,* December 30, 1862, reprinted in the *New York Times,* December 31, 1864. The historian who first noted the article's importance was La Wanda Cox, in *Lincoln and Black Freedom: A Study in Presidential Leadership* (Columbia: University of South Carolina Press, 1981), 13.

59. Henry J. Raymond to Lincoln, November 22, 1862, LPLC; Lincoln to Raymond, December 7, 1862, *Collected Works,* 5:544.
60. William Lloyd Garrison to Francis W. Newman, in *Let the Oppressed Go Free,* 5:223-24.
61. Gideon Welles, "The History of Emancipation," *Galaxy,* December 1872, 840.
62. *New York Times,* January 3, 1863.
63. *Chicago Times* quoted in V. Jacque Voegeli, *Free but Not Equal* (Chicago: University of Chicago Press, 1967), 76-77; (New York) *Irish-American,* January 17, 1863.
64. Mark E. Neely Jr., *The Emancipation Proclamation: Our Second Declaration of Independence* (Fort Wayne, IN: Lincoln National Life Foundation, n.d.), [14].
65. Garrison, *Let the Oppressed Go Free,* 5:131.
66. Harriet Beecher Stowe in the *Boston Watchman and Reflector,* February 6, 1864, reprinted in Mitgang, *Lincoln as They Saw Him,* 377.
67. Richard McLaughlin to Lincoln, January 9, 1863; Henry N. Cobb to Lincoln, April 6, 1864, both LPLC.
68. Three years earlier, Livermore had covered the Republican National Convention in Chicago that nominated Lincoln for President—by her claim the only woman in the press section. See Harold Holzer, *Lincoln President-Elect: Abraham Lincoln and the Great Secession Winter, 1860-1862* (New York: Simon and Schuster, 2008), 367.
69. Mary A. Livermore, *My Story of the War: A Woman's Narrative of Four Years Personal Experience as a Nurse in the Union Army . . . ,* ed. Nina Silber (New York: Arno Press, 1972 [1887]), 556.
70. Mary Livermore to Lincoln, October 11, 1863, LPLC.
71. "Signatures of Ladies . . . ," appended to invitation to the Chicago fair, October 1863, petition in LPLC. See also Mrs. A. H. Hoge and Mrs. D. P. Livermore to Lincoln, October 21, 1863, invitation with brochure about the fair, also in LPLC.

72. Stoddard, *Lincoln's White House Secretary*, 291.
73. Owen Lovejoy to Lincoln, October 14, 1863, LPLC.
74. Isaac Arnold to Lincoln, October 21, 1863, LPLC.
75. Abraham Lincoln to "Ladies having in charge of the North-Western Fair for the Sanitary Commission Chicago, Illinois," October 23, 1863, *Collected Works*, 6:539.
76. Mary Livermore to Abraham Lincoln, November 11, 1863, LPLC.
77. *Sanitary Commission Bulletin* 1 (December 1, 1863), 66, 69–70.
78. Lincoln donated a copy of his December 8, 1863, Amnesty and Reconstruction Proclamation, at Ohio senator John Sherman's request. It was purchased by John D. Caldwell, general secretary of the National Union Association of Ohio. See Caldwell to Lincoln, April 4, 1864, LPLC; see also Scott L. Gamper, "Lincoln Originals: Abraham Lincoln Documents in the Collections of the Cincinnati Historical Society Library," *Ohio Valley History* 9 (Winter 2009): 79–83.
79. Endorsement on the back of invitation from Thomas B. Bryan to Abraham Lincoln, November 22, 1860, LPLC; reply reprinted in *Collected Works*, 4:144.
80. Mary Livermore to Lincoln, November 26, 1863, LPLC.
81. Lincoln to James H. Hoes, December 17, 1863, *Collected Works*, 7:75.
82. J. J. Richards to Lincoln, December 8, 1863, LPLC.
83. A. Kidder to Lincoln, January 6, 1864, LPLC.
84. Lossing, *Pictorial History of the Civil War*, 3:564n1.
85. Thomas B. Bryan to Lincoln, January 7, 1864, LPLC; Lincoln to Bryan, January 18, 1864, *Collected Works*, 7:135.
86. Loretta Ebert, "With the President's Permission: How New York State Acquired the Emancipation Proclamation," New York State Library, 9. The author is grateful to Ms. Ebert, director of the New York State Library, and Chris

Ward, New York State archivist, for sharing information
and material relating to the Albany fair. "Aladdin" quote is
from the (Albany, NY) *Canteen,* February 22, 1864, 1-2.

87. F. W. Seward to Mrs. William Barnes, January 4, 1864, in
Frederick William Seward, *Letters, 1864-1906,* New York
State Library, Manuscripts and Special Collections 14977,
reprinted in "With the President's Permission," 5. Mrs.
Barnes held the official position of corresponding secre-
tary of the bazaar committee.

88. Barnes and rhyme, ibid., 5, 10, 11.

89. *Albany Evening Journal,* March 2, 1865; William Barnes to
Gerrit Smith, March 17, 1864, March 10, 1864, Gerrit Smith
Papers, Arents Library, Syracuse University, microfilm
copy in New York State Library, cited in "With the
President's Permission," 11-12.

90. D. P. Bacon to Lincoln, April 25, 1864, LPLC. For the text
of the letter, see Lincoln to Mary Lincoln, August 8, 1863,
Collected Works, 6:371-72.

91. The fair is described in Catherine Clinton, "Mrs. Lincoln in
Wartime New York," in Harold Holzer, ed., *Lincoln and New
York* (New York: New-York Historical Society, 2009), 214.

92. Livermore, *My Story of the War,* 429-30.

93. For the April 15, 1861 proclamation calling out the militia
and convening a special session of Congress, see *Collected
Works,* 4: 331-32.

94. Schuyler Colfax, *Life and Principles of Abraham Lincoln*
(Philadelphia: James B. Rodgers, 1865), 16-17.

95. *Frederick Douglass: Selected Speeches and Writings,* 523, 525.

96. "The Proclamation," published in *Atlantic Monthly* 11
(February 1863): 251; Barry Gray to Lincoln, ca. January
1863, LPLC. "The Emancipation Group" (1879) was
composed for the dedication of Thomas Ball's statue of
the same name, showing Lincoln and a kneeling slave. See
Holzer, *The Lincoln Anthology,* 235.

97. Holzer, *The Lincoln Anthology*, 441.
98. Lincoln to James C. Conkling, August 26, 1863, *Collected Works*, 6: 408–10. Lincoln was tempted to deliver the words in person but, realizing he could not "be absent from here, so long as a visit there, would require" (406), urged his friend Conkling to read it in his behalf.
99. Stowe quoted in Mitgang, *Lincoln as They Saw Him*, 377.
100. "Editor's Table," *Continental Monthly* 3 (January 1863): 126, quoted in Eric Foner, *The Fiery Trial: Abraham Lincoln and American Slavery* (New York: W. W. Norton, 2010), 237.
101. Annual Message to Congress, December 1, 1862, Second Inaugural Address, March 4, 1865, *Collected Works*, 5:537, 8:332–33.
102. Edward Everett Hale reminiscence in *Recollected Words of Abraham Lincoln*, ed. Don E. Fehrenbacher and Virginia Fehrenbacher (Stanford, CA: Stanford University Press, 1996), 433.
103. Report on Fox Detroit, June 23, 2011, published on http://www.myfoxdetroit.com; *Detroit Free Press*, June 27, 2011; "Original Emancipation Proclamation to Be Displayed at The Henry Ford, June 20–22, 2011íí museum press release, May 19, 2011.

3. SACRED EFFIGIES

1. Frederick Douglass, *Life and Times of Frederick Douglass Written by Himself* (orig. pub. 1893), in *Frederick Douglass: Autobiographies*, ed. Henry Louis Gates Jr. (New York: Library of America, 1993), 792; *Douglass' Monthly*, October 1862. See also "Rejoicing over the Emancipation Proclamation," *Weekly Anglo-African*, January 10, 1863.
2. *The Diary of George Templeton Strong*, ed. Allan Nevins and Milton Halsey Thomas (New York: Macmillan, 1952), 3:284.

3. Quoted in Allen C. Guelzo, *Lincoln's Emancipation Proclamation* (New York: Simon and Schuster, 2005), 181.

4. The scribe incorrectly copied the boilerplate "In witness thereof" clause that routinely ended all official proclamations of the day.

5. *Baltimore Sun*, January 2, 1863.

6. Francis B. Carpenter, *Six Months at the White House: The Story of a Picture* (New York: Hurd and Houghton, 1867), 269–70.

7. Francis B. Carpenter, "Anecdotes and Reminiscences," in Henry J. Raymond, *Life and Public Services of Abraham Lincoln* (New York: Derby and Miller, 1865), 763–64.

8. Harold Holzer, "The Bearding of the President, 1860: The Printmakers Put on [H]airs," *Lincoln Herald* 78 (Fall 1976): 99–101.

9. *Bronze Group Commemorating Emancipation. A Gift to the City of Boston from Hon. Moses Kimball. Dedicated December 6, 1879,* City Document No. 126 (Boston: Boston City Council, 1879), 28–29.

10. See David Brion Davis, "The Emancipation Moment," in Gabor Boritt, ed., *Lincoln the War President* (New York: Oxford University Press, 1992), 65–88. As Davis shrewdly observed: "The context and even content of Lincoln's words did not really matter. They would soon be forgotten. What mattered was the symbolic emancipation moment" (88).

11. Charles Eberstadt, *Lincoln's Emancipation Proclamation* (New York: Duschnes Crawford, 1950), 41. Though the book is sixty years old, and inadequate and somewhat confusing as well, this is still the standard reference guide to the early printings of the preliminary and final proclamations.

12. Ibid.

13. Ibid., 39–40.

14. Lincoln to Bryan, January 18, 1864, in *The Collected Works of Abraham Lincoln,* ed. Roy P. Basler (hereinafter cited as *Collected Works*) (New Brunswick, NJ: Rutgers University Press, 1953–1955), 7:135.

15. A. Kidder to Lincoln, January 6, 1864, Lincoln Papers, Library of Congress.

16. Eberstadt, *Lincoln's Emancipation Proclamation.*

17. L. Franklin Smith, *Proclamation of Emancipation. The Second Declaration of Independence! By President Lincoln. January 1st, 1863,* advertising poster, Philadelphia, 1865, original in the Stern Collection, Library of Congress; Lincoln's comment in Carpenter, *Six Months at the White House,* 158.

18. Notation on the back of the copy of the photograph in the collection of the Indiana Historical Society. For the full text, see Harold Holzer, ed., *Abraham Lincoln Portrayed in the Collections of the Indiana Historical Society* (Indianapolis: Indiana Historical Society Press, 2006), 99.

19. Harold Holzer, Mark E. Neely, and Gabor S. Boritt, *The Lincoln Image: Abraham Lincoln and the Popular Print* (New York: Scribner's, 1984), 102, 104–5.

20. Address at Independence Hall, February 22, 1861, in *Collected Works,* 4:240.

21. Richard L. Pease, "Edward Dalton Marchant," *Vineyard Gazette,* August 26, 1887.

22. David E. Long, *The Jewel of Liberty: Abraham Lincoln's Re-election and the End of Slavery* (Mechanicsburg, PA: Stackpole Books, 1994), 170.

23. Carpenter, *Six Months at the White House,* 11–12.

24. Ibid., 12–13.

25. *Philadelphia Daily Age,* March 7, 1864, original in the Houghton Library, Harvard University.

26. Carpenter, *Six Months at the White House,* 19, 20, 18–27.

27. Francis B. Carpenter, "Anecdotes and Reminiscences," 763-64.
28. Quoted in the advertising endpapers of Carpenter, *Six Months at the White House*. The savvy artist adroitly used his memoir to promote his painting, and used his painting to promote his memoir.
29. The original order book is in the collection of the Chicago Historical Society.
30. Robert T. Lincoln to Warren C. Crane, December 15, 1903, Robert Todd Lincoln Letter File, Abraham Lincoln Presidential Library and Museum, Springfield, IL.
31. Quoted in Roy P. Basler, *The Lincoln Legend: A Study in Changing Conceptions* (Boston: Houghton Mifflin, 1935), 202-3.
32. For depictions of and an excellent history of this misunderstood abolitionist emblem, see Kirk Savage, *Standing Soldiers, Kneeling Slaves: Race, War, and Monument in Nineteenth-Century America* (Princeton, NJ: Princeton University Press, 1997), 20-23. An excellent online introduction can be found in Martin Katz-Hyman, "Anti-Slavery Images," for the Colonial Williamsburg Teacher Resource website, and accessible at www.history.org/history/teaching/enewesletter/volume2/february04/iotm.cfm.
33. Quoted in Savage, *Standing Soldiers, Kneeling Slaves*, 21.
34. Currier and Ives left no records of its sales figures, but the large number of surviving copies of this lithograph attests informally but convincingly to its commercial success. Ironically, the New York print publishers may have stolen the design from a print issued earlier by the little-known Chicago firm of J. Waeschle, whose caption suggests it was inspired by the preliminary, not final, proclamation, much less by Lincoln's death and martyrdom. Still, it is impossible to know for certain which print came first (competitors

routinely pirated Currier and Ives images in their day). For a full discussion, see Harold Holzer, Gabor S. Boritt, and Mark E. Neely Jr., *Changing the Lincoln Image* (Fort Wayne, IN: Louis A. Warren Lincoln Library and Museum, 1985), 42–48.

35. David Brion Davis, *The Emancipation Moment,* 22nd annual Robert Fortenbaugh Memorial Lecture (Gettysburg, PA: Gettysburg College, 1983), 10.

36. The original is in the collection of the Union League Club of New York.

37. Quoted from a slave narrative in David Herbert Donald, *Lincoln* (New York: Simon and Schuster, 1995), 576.

38. Quoted in Peter Marzio, *The Democratic Art: Chromolithography, 1840–1900—Pictures for a 19th-Century America* (Boston: David R. Godine, 1979), 104. Douglass was reacting specifically to endorse a new lithographic portrait of Hiram Revels, the African American elected to the Mississippi U.S. Senate seat once held by Jefferson Davis.

39. James M. McPherson, *The Negro's Civil War: How American Negroes Felt and Acted During the War for the Union* (Urbana: University of Illinois Press, 1982 [1965]), 107.

40. Sarah M. Barnes to D. S. Bull, April 4, 1867, transcript in the Collection of Books, Maps, Manuscripts, Broadsides and Trade Catalogues, No. 292 (2003), Denning House Antiquarian Books, Salisbury Mills, NY. The author is indebted to Michael Parrish for bringing this recollection to his attention. Barnes recorded her original entry in "Negro Dialect," which I have restored to standard English.

41. Mary Lincoln to Sen. Charles Sumner, September 6, 1866, in *Mary Todd Lincoln: Her Life and Letters,* ed. Justin G. Turner and Linda Levitt Turner (New York: Alfred A. Knopf, 1972), 387.

42. "Grace Greenwood" (S. J. C. Lippincott) quoted in Glenn V. Sherwood, *Labor of Love: The Life and Art of Vinnie Ream* (Hygiene, CO: SunShine Press, 1997), 175; Taft quoted in Donald Charles Durman, *He Belongs to the Ages: The statues of Abraham Lincoln* (Ann Arbor, MI: Edwards Brothers, 1951), 36.

43. For a report of the dedication, see *New York Times*, February 13, 1878; for the accident, see Sherwood, *Labor of Love*, 175-76.

44. Rogers fulfilled his commission in 1871. See Donald Charles Durman, *He Belongs to the Ages: The Statues of Abraham Lincoln* (Ann Arbor, MI: Edwards Bros., 1951), 38.

45. Louis A. Warren, "A Negro Artist's Oil Painting of Lincoln," *Lincoln Lore* 1297 (February 15, 1954).

46. Bowser's original banner is in the Library of Congress.

47. *New York Times*, June 1, 1865.

48. See Durman, *He Belongs to the Ages*, 45. A superb account of the statue's creation—and the emotions it still arouses— can be found in Savage, *Standing Soldiers, Kneeling Slaves;* for the Ball project, see esp. 112-18. For Ball's own recollections, see Thomas Ball, *My Threescore Years and Ten: An Autobiography* (Boston: Roberts Bros., 1891), 252-53.

49. *Frederick Douglass: Selected Speeches and Writings*, ed. Philip Foner and Yuval Taylor (Chicago: Lawrence Hill Books, 1999), 618-20, 624.

50. Durman, *He Belongs to the Ages*, 46, 50; *Bronze Group Commemorating Emancipation*, 28.

51. David Blight, *Race and Reunion: The Civil War in American Memory* (Cambridge, MA: Harvard University Press, 2001), 369.

52. Edna Greene Medford, "Imagined Promises, Bitter Realities: African Americans and the Meaning of the Emancipation Proclamation," in Harold Holzer, Edna

Greene Medford, and Frank J. Williams, *The Emancipation Proclamation: Three Views* (Baton Rouge: Louisiana State University Press, 2006), 45.

53. Romare Bearden and Harry Henderson, *A History of African-American Artists from 1792 to the Present* (New York: Pantheon, 1993), 365.

54. Steve Conn, "The Politics of Painting: Horace Pippin the Historian," *American Studies* 38 (Spring 1997): 17. See also Richard J. Powell, "Re-Creating American History," in Judith E. Stein et al., *I Tell My Heart: The Art of Horace Pippin* (Philadelphia: Pennsylvania Academy of the Fine Arts, 1993), 73–74, 78.

55. "The Ben Maltz Gallery at Otis College of Art and Design Is Pleased to Present This Exhibition: Travis Somerville— Dedicated to the Proposition," museum press release, June 2009.

56. Historian Gabor Boritt tracked this iconographic trans-formation in public sculpture and public memory in *The Gettysburg Gospel: The Lincoln Speech That Nobody Knows* (New York: Simon and Schuster, 2006), 163–203.

57. Christopher A. Thomas, *The Lincoln Memorial and American Life* (Princeton, NJ: Princeton University Press, 2002), 157.

58. Harold Holzer, ed., *The Lincoln Anthology: Great Writers on His Life and Legacy from 1860 to Now* (New York: Library of America, 2009), 432–34.

59. Scott Sandage, "A Marble House Divided: The Lincoln Memorial, the Civil Rights Movement, and the Politics of Memory, 1939–1963," *Journal of American History* 80 (June 1993): 146–47.

60. Quoted in Conn, "The Politics of Painting," 15.

61. A. Philip Randolph, "Why the Interracial Youth March for Integrated Schools," quoted in Sandage, "A Marble House Divided," 159.

ACKNOWLEDGMENTS

I am tremendously indebted to my friend Henry Louis Gates Jr., chairman of the W. E. B. Du Bois Institute for African and African American Research at Harvard University, for inviting me to deliver the Nathan I. Huggins Lectures at the Institute in October 2010. Those lectures form the core of this book. To Skip Gates and the entire staff, particularly executive director Vera Grant, Professor John Stauffer, and Dr. Gates's researcher Joanne Kendall, I express my profound thanks for a truly unforgettable opportunity.

I have been writing about Emancipation Proclamation iconography for many years, and while I designed this book's exploration of the subject as a kind of valedictory based on decades of reflection and interpretation, I do want to acknowledge my longstanding debt and gratitude to colleagues with whom I have written and conducted research on this subject since the 1980s, especially Mark E. Neely Jr. of the Pennsylvania State University, Gabor Boritt of Gettysburg College, and Edna Greene Medford of Howard University.

199

ACKNOWLEDGMENTS

Sincere thanks go, too, to registrars and other officials at a number of museums and libraries around the country who so speedily responded to requests for permission to reproduce the images in this book: Kara S. Vetter at the Indiana State Museum and her colleague Cindy Van Horn; Susan Sutton at the Indiana Historical Society; Martin Sullivan, director, and Richard Sorensen, reproduction rights coordinator, at the Smithsonian American Art Museum in Washington; Kim Mitchell at the Museum of Modern Art in New York; John J. Meko Jr., executive director of the Foundations of the Union League of Philadelphia, and James G. Mundy Jr., the league's director of library and historical collections; Lisa Marine and Sheri Dolfen at the Wisconsin Historical Society; Adria Patterson, curator of the Amistad Collection at the Wadsworth Atheneum Museum of Art; publisher Lisa Hughes and Lauren Effron Posin at the *New Yorker* magazine and Leigh Montville at Condé Nast; Anthony Calnek, vice president and worldwide director of media services at Sotheby's; cartoonist extraordinaire Steve Sack of the *Minneapolis Star Tribune;* and the ever-efficient staff at the Library of Congress in Washington. At my own office at the Metropolitan Museum of Art, Kraig Smith and Rebecca Schear provided their usual crucial and much-appreciated after-hours assistance.

Important advice came from Professor Allen Guelzo at Gettysburg College; Frank J. Williams, chairman of the

200

Lincoln Forum; Christine Ward at the New York State Archives; independent scholar Jason Emerson; Loretta Ebert of the New York State Library; historian Michael Parrish; and Caroline Welling Van Deusen, great-granddaughter of William C. Welling, editor of the *National Intelligencer* during the Civil War. And tech-savvy documents arrived at the drop of an e-mail thanks to my able and intrepid research assistants Avi Mowshowitz and Leland Chamlin.

Finally, I have truly enjoyed the opportunity to work at last with Joyce Seltzer (and her exhaustingly thorough assistants Jeannette Estruth and Brian Distelberg) at Harvard University Press to bring these lectures into form worthy of print. Thus, what began with the privilege of participating in a legendary lecture series has ended with the equally exciting chance to work with a legendary editor and publisher. I am grateful indeed to everyone who made the experience so rewarding from beginning to end.

INDEX